Manga Artists'

COPIC MARKER

Coloring Techniques

Manga Artists' Copic Marker Coloring Techniques
First Published in 2021 by Zakka Workshop, a division of World Book Media, LLC

www.zakkaworkshop.com
134 Federal Street
Salem, MA 01970 USA
info@zakkaworkshop.com

COPIC KANTAN JOTATSU IRONURI LESSON
Copyright ©2016 GENKOSHA Co. Ltd. All rights reserved.
Original Japanese edition published by GENKOSHA Co. Ltd.
English language licensed by World Book Media, LLC, USA via Tuttle-Mori Agency, Inc., Tokyo, Japan

Editor: Toshimitsu Katsuyama
Editor in charge: Hiroshi Kiriaki
Publisher: Hiroshi Kitahara
Editing staff: Wedge Holdings CO., LTD
Design: Eriko Arai, Wedge Holdings CO., LTD
Photography: Takaaki Taniguchi and Yoshie Tamura
Translator: Kyoko Matthews
English editor: Stefanie Laufersweiler

We have made every effort to ensure the accuracy and completeness of these instructions. We cannot, however, be responsible for human error, typographical mistakes, or variations in individual work.

ISBN: 978-1-940552-56-9

Printed in China

10 9 8 7 6 5 4 3

Manga Artists'

COPIC MARKER

Coloring Techniques

How to Blend, Mix and Layer Color Like a Pro

**SHIN, Yue, Maripori, Junko Kitamura,
Suzu Kawana, Ramiru Kirisaki**

CONTENTS

CHAPTER 1 Basic Coloring Methods 7

COPIC MARKER BASICS 8
Marker Types & Tips 8
The Copic Marker Color System 9
How to Draw Lines 10
How to Apply Color 12
How to Mix Colors 14
How to Color with Gradation 16
Using Colorless Blender 17
Coloring Tips & Fixes 18
Using Opaque White 19

OTHER TOOLS & MATERIALS 20
Choosing a Drawing Pen 20
Selecting Paper 22

USING COPIC MARKERS TO CREATE ART 24
Selecting Colors 24
MANGA ARTIST AT WORK: Maripori 26
ANALOG > DIGITAL:
Converting Your Line Drawings
to Digital 28
ANALOG > DIGITAL:
Printing Out Your Art 30

CHAPTER 2 Manga Artists' Coloring Techniques 31

SECTION 1 COLORING THE FACE & SKIN . . . 32
How to Color Skin 32
How to Color Eyes 38
How to Color Hair 42
How to Color Lips 46
How to Color Sweat & Tears 49
MANGA ARTIST AT WORK: Suzu Kawana . . . 52
ANALOG > DIGITAL: Processing Photos to
Create Line Drawings 54

SECTION 2 COLORING CLOTHES 56
How to Color Fabric 56
How to Color Fur 62
How to Color Leather 65
How to Color Frills 66
How to Color Tights 68
MANGA ARTIST AT WORK: Yue 70
ANALOG > DIGITAL:
Create Digital Color Samples 72

SECTION 3 COLORING ACCESSORIES 74
How to Color a Lantern 74
How to Color a Candle 75
How to Color a Trumpet 76
How to Color a Dagger 77
How to Color a Pouch 78
How to Color a Diamond 79
How to Color an Emerald 80
How to Color a Sapphire 81
How to Color a Pearl 82
How to Color an Apple 83
How to Color Grapes 84
How to Color a Parfait 85
How to Color Cake 86
MANGA ARTIST AT WORK: SHIN 88
ANALOG > DIGITAL:
Layering Color: Part One 90

SECTION 4 **COLORING NATURE** · · · · · · · · · 92

How to Color Cherry Blossoms · · · · · · · · · ·92

How to Color Roses · · · · · · · · · · · · · · · · · ·93

How to Color Hydrangeas · · · · · · · · · · · · · ·94

How to Color Pansies · · · · · · · · · · · · · · · · ·95

How to Color Wood · · · · · · · · · · · · · · · · · ·96

How to Color Grass · · · · · · · · · · · · · · · · · ·97

SECTION 5 **COLORING BACKGROUNDS** · · · · 98

How to Color a Cloudy Sky · · · · · · · · · · · · · ·98

How to Color a Night Sky · · · · · · · · · · · · 102

How to Color Rain · · · · · · · · · · · · · · · · · 104

How to Color the Ocean · · · · · · · · · · · · · · 104

How to Color Lake Water · · · · · · · · · · · · · 106

ANALOG > DIGITAL:

Layering Color: Part Two · · · · · · · · · · · · · 108

MANGA ARTIST AT WORK:

Junko Kitamura · · · · · · · · · · · · · · · · · · · 110

CHAPTER 3 Fixing Mistakes and Growing Your Skills 113

SECTION 1 **MAKING CORRECTIONS** · · · · · · 114

Common Fixes · 114

Other Removal Methods · · · · · · · · · · · · · · 115

SECTION 2 **ADVANCED TECHNIQUES** · · · · 116

Considering the Light Source · · · · · · · · · · 116

Putting Color in Perspective · · · · · · · · · · · 116

Layering the Same Color · · · · · · · · · · · · · 117

Gradation with Multiple Colors · · · · · · · · 118

SECTION 3 **TRYING DIFFERENT SURFACES** 120

Smooth vs. Textured Paper · · · · · · · · · · · 120

Art Paper · 120

Special Finish Paper · · · · · · · · · · · · · · · · 121

Patterned Paper · · · · · · · · · · · · · · · · · · · 121

ANALOG > DIGITAL:

Tips for Digitizing Copic Artwork · · · · · · · 122

ANALOG > DIGITAL: Digitize Original

Artwork Using Your Phone · · · · · · · · · · · 124

MANGA ARTIST AT WORK: Ramiru Kirisaki 126

CHAPTER 4 Copic Marker FAQs 129

Coloring Q&A · 130

Copic Q&A . · 134

ANALOG > DIGITAL:

Submitting Your Files to the Printer · · · · · 136

ANALOG > DIGITAL:

Making Products with Your Art · · · · · · · · 138

Pattern Gallery · · · · · · · · · · · · · · · · · · · 140

Resources · 144

INTRODUCTION

Copic pens and markers are enormously popular for drawing and coloring illustrations. In this book, we begin with the basics of how they work; then, six illustrators show you how to use them, through detailed explanations and drawings. You'll also find valuable information on how to use your computer and even your phone to make creating art more convenient, and a section dedicated to answering Copic users' most frequently asked questions.

Whether you're a novice or an artist with some experience, you'll discover techniques, tips and inspiration to guide you in making better art. Don't be discouraged if your drawings don't look like the samples you see on these pages. Each artist works a little differently, and every artist was a beginner once. With time and lots of practice, your skills will improve and your own style and preferences will emerge. We hope this book brings some color to your life and helps your drawings come closer to what you want them to be.

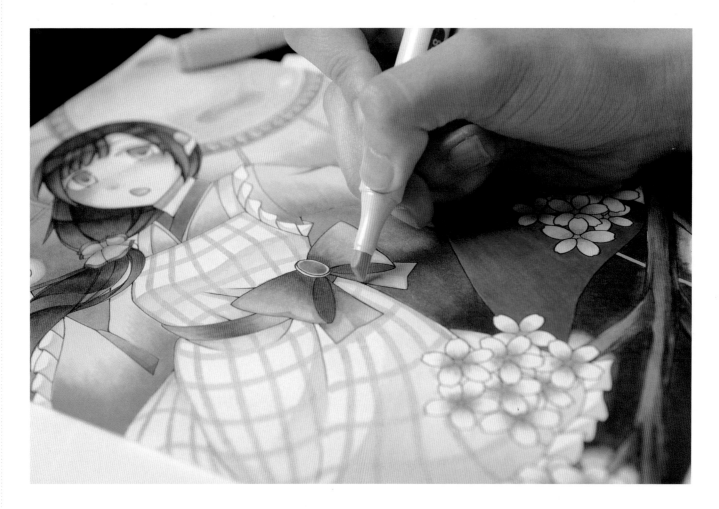

BASIC COLORING METHODS

Let's cover the basics of drawing and coloring with Copic pens and markers, and explore different papers and coloring tools. Learn techniques for mixing and applying color, and how to make adjustments and fix mistakes.

COPIC MARKER BASICS

Copic markers are high quality alcohol-based markers used for manga, fashion illustration, architectural drawings, coloring books, and so much more! Copic markers are particularly beloved among artists for their incredible blending abilities and wide variety of brilliant colors. Copic markers may seem complicated and intimidating, but once you understand the basics, you'll be ready to start drawing in no time!

Marker Types & Tips

There are actually four different types of Copic markers: Original, Sketch, Ciao, and Wide. This book will focus on the two main types, Sketch and Ciao, both of which feature a chisel tip on one end and a brush tip on the other.

Copic Sketch markers are the most popular type among professional artists and are available in 358 colors, while Copic Ciao markers are a more affordable alternative and are available in 180 colors. Copic Sketch markers have an oval body and can hold more ink, while Copic Ciao markers have a round body and are smaller.

Although there a few slight differences between the two types of markers, they both offer the same great quality. Choose whichever marker type is most comfortable for you!

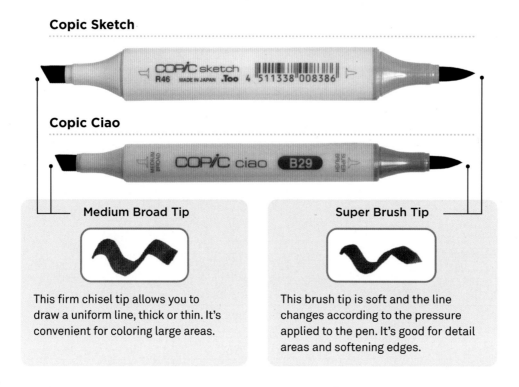

Copic Sketch

Copic Ciao

Medium Broad Tip

This firm chisel tip allows you to draw a uniform line, thick or thin. It's convenient for coloring large areas.

Super Brush Tip

This brush tip is soft and the line changes according to the pressure applied to the pen. It's good for detail areas and softening edges.

The Copic Marker Color System

Copic markers are renowned for their wide variety of colors. In fact, Copic markers even have their own system for identifying colors by code. Understanding this color system will help you choose the perfect Copic marker for your art.

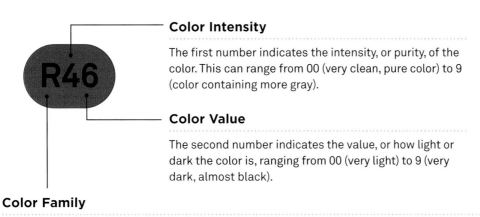

Color Intensity

The first number indicates the intensity, or purity, of the color. This can range from 00 (very clean, pure color) to 9 (color containing more gray).

Color Value

The second number indicates the value, or how light or dark the color is, ranging from 00 (very light) to 9 (very dark, almost black).

Color Family

Letters are used to represent the color family, or hue. In the example above, R means that the marker is red. As you'll see in the key below, most of the color families are pretty straightforward. However, there are four different color families of gray, plus color families for earth colors and fluorescent colors.

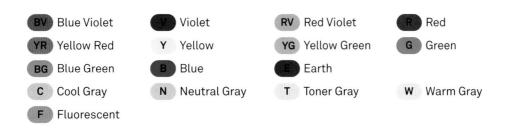

The most important thing to remember about the Copic marker color system is that the numbers are two separate numbers. So in the example above, the color code is R four-six, not R forty-six. This will help you understand the properties of the color.

How to Draw Lines

Adjust the way you grip the pen depending on the line you want to draw. The nib (or tip) you choose can also change the look of your line.

Thin Lines

Apply just the tips of the Super Brush and the medium broad pen against the paper to draw a line with each. You can achieve a thin line with both, but the brush tip tends to be uneven compared to the chisel tip.

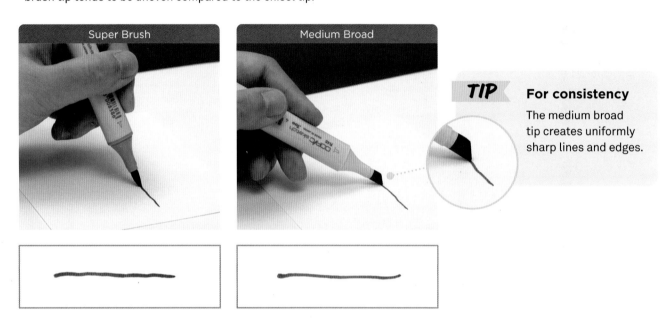

TIP **For consistency**
The medium broad tip creates uniformly sharp lines and edges.

Thick Lines

When using the Super Brush for a thick line, lay the nib down to draw. When using the medium broad chisel tip, apply the angled end against the paper for a thicker line. Draw slowly for consistent color.

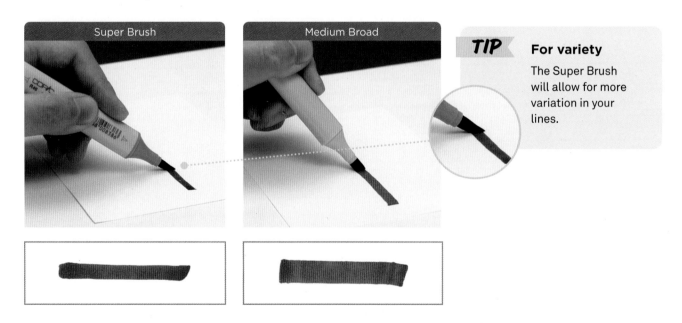

TIP **For variety**
The Super Brush will allow for more variation in your lines.

A Variety of Lines

Use the different nibs to create unique line effects. For example, the Super Brush can be used to draw fading lines that taper off at the end, freeform circles, and dots.

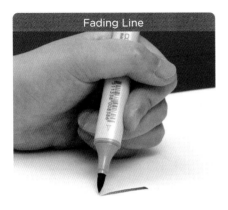
Fading Line

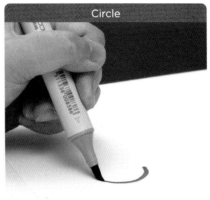
Circle

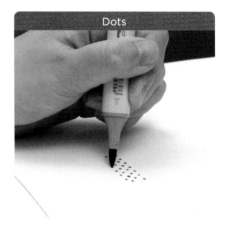
Dots

How to Apply Color

There's an art to adding color to your illustrations. If it looks streaky or uneven, check your coloring method.

Coloring Evenly

The pressure you place on your marker as you apply color affects how the ink soaks into the paper. If your color appears streaky or uneven, slow down and color with more consistent pressure, at a uniform speed. Don't lift the marker off the paper as you fill in areas. Decide ahead of time the area you plan to color in each pass, to make it easier for you to avoid lifting your marker as you work. Slightly overlapping your strokes will give you even coverage once the ink is dry.

Don't

Do

Coloring too quickly and with inconsistent pressure creates an uneven, unblended look.

Coloring carefully, with uniform speed and pressure, results in an even, consistent finish.

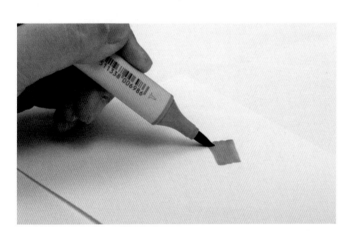

Super Brush Tip for Details

When coloring smaller areas, the Super Brush tip is recommended. It offers good coverage and well-blended edges.

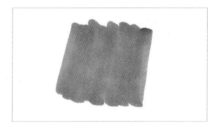

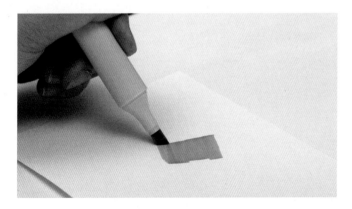

Medium Broad Tip for Large Areas

The medium broad tip is recommended for larger areas. Overlap your strokes before the ink dries for even coverage.

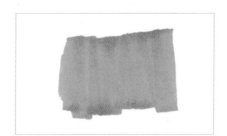

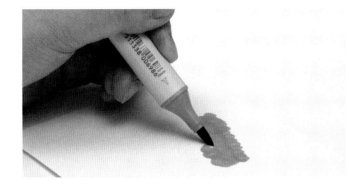

Coloring by Drawing in Circles

If you want to correct or avoid unevenness remaining as stripes, add or apply color in small circular strokes. Layer circles before the ink dries.

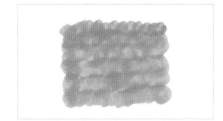

Layering to Fix Uneven Color

Before the ink dries, layer the uneven area with more color. The color becomes darker but the ink blends well for more evenness.

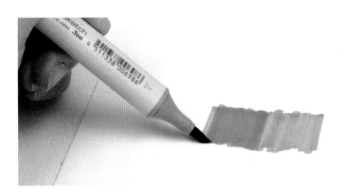

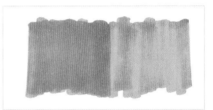

Take Advantage of Unevenness

You can use uneven color purposely to express texture and form. Adjusting your strokes to be even in some areas and uneven in others can help convey the roundness of a mug as shown, or the texture of natural materials such as wood grain and water.

Make your strokes follow the form

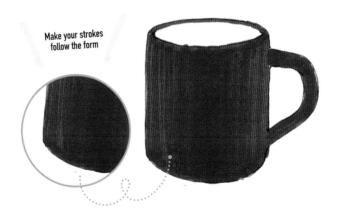

TRY IT!

Clean the marker tip

When you cross a dark, smearable main line or layer a light color over a dark color, the tip of the marker gets dirty. If you color other areas without cleaning it first, unwanted color may show up on your paper. Always check marker tips for unwanted color. Clean contaminated tips by drawing with them on scrap paper a few times until the color is clean again.

How to Mix Colors

You can create your own original colors by mixing them. Let's find your favorite color.

Make Green

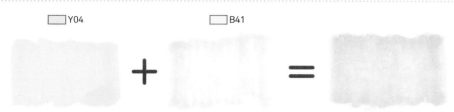

Combining lighter colors creates brighter hues. Combine darker tones to create darker, less intense color mixtures. The type of yellow and blue you choose will affect whether the resulting green looks yellowish or bluish.

TIP **Y+B = Green**

Mixing a Y-series yellow and a B-series blue creates a more yellowish green than the greens you will find in the G-series.

Make Purple

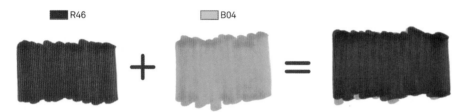

When you mix intense reds and blues, be careful not to get too dark. Also, colors mix differently on different types of paper. Mixing on paper that doesn't absorb ink well will cause the mixture to change in appearance as it dries.

TIP **R+B = Purple**

For a lighter purple, mix light blue and light pink. When you mix darker colors, watch the order of how you layer the colors (see next page).

Make Orange

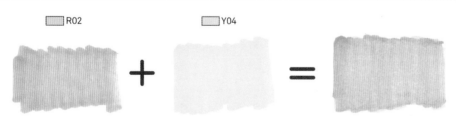

When mixing orange, use a lighter red from the R-series, because the yellow in your mixture won't show with darker reds. Combining lighter tones will allow you to play with the balance of the colors in the mixture.

TIP **R+Y = Orange**

To mix a light orange, use an R-series pink and a Y-series hue that's close to beige. Use a bright yellow for a brighter orange.

Lessen the Intensity of Bright Colors

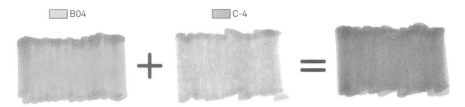

Adding gray tone to a bright color will lessen its intensity. You can create darker shades of the brighter color by changing the gray that you add, but choose a gray that's consistent with the temperature of the color.

TIP **Which gray to add**

Layer C-series cool grays on cool colors, and W-series warm grays on warm colors, to create less intense shades. N-series neutral grays can be used to dull any bright color.

Smooth the Transition Between Layered Colors

To create a smooth transition (or gradation) of color after you've applied one color over part of another, go over the boundary between the two with the first color. This will blur the hard edge, creating a more gradual change. This gradation effect works best when you choose a lighter color for the first color.

How Layering Order Affects Mixed Color

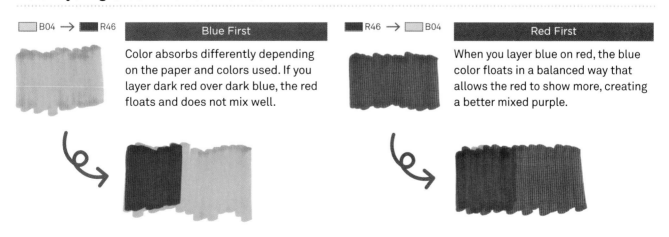

Blue First

Color absorbs differently depending on the paper and colors used. If you layer dark red over dark blue, the red floats and does not mix well.

Red First

When you layer blue on red, the blue color floats in a balanced way that allows the red to show more, creating a better mixed purple.

How to Color with Gradation

Creating smooth transitions of color will make your illustrations look more dimensional.

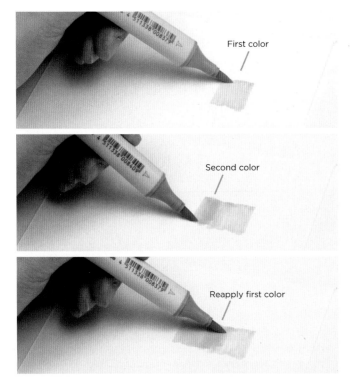

First color

Second color

Reapply first color

Two-Color Gradation

Colors used

R32 YR31

Start with a layer of the first color, applied with the tip facing the side where the gradation will occur.

Next, apply the second color over part of the first, before the first color dries. Then, quickly reapply the first color over the edge where the two colors meet, to soften it. Before the first color dries, go over all of the area again using the first color to adjust overall.

Same-Tone Gradation

Colors used

R30 R32 R46

When you color using same-tone gradation, start with the darker color. Then continue by adding the second color, blending into where you left off with the first color as you go. Finally, add the lightest third color, blending it into the second color.

Layer the colors quickly, before the ink dries. They should be from the same color family but different enough in lightness/brightness that the gradation is noticeable.

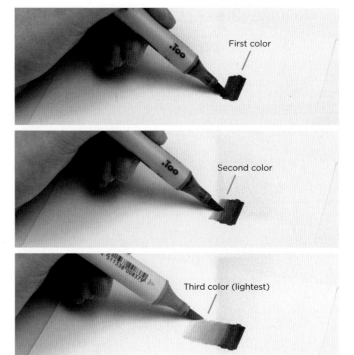

First color

Second color

Third color (lightest)

Using Colorless Blender

No. 0, also known as colorless blender, is a transparent marker that doesn't have pigment. It is used to add special effects.

Create Soft Color

First, apply No. 0 on the area where you plan to add color. When you add color on the colorless blender, the color appears softer. You can create light gradation without using much ink.

Make Patterns

Dropping colorless blender onto color that has already been applied can create a bubble-like pattern that moves the color around. Dropped No. 0 spreads on paper slowly.

Remove Color

Wet a cotton swab or tissue with colorless blender and use it to lift and remove color. Dark color can be removed easily, but you may not be able to remove colors completely, depending on the paper.

Coloring Tips & Fixes

Try using colored pencils with Copic markers to make adjustments and fix common mistakes.

Blend Strokes or Adjust Details

Colored pencils can be used with Copic markers in a couple of ways. After coloring with colored pencils, apply marker over it to blend or soften the pencil strokes. Or, after coloring with markers, you can adjust details using colored pencils.

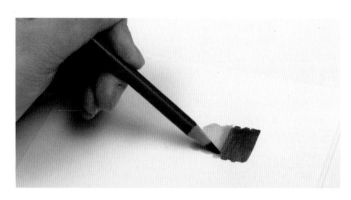

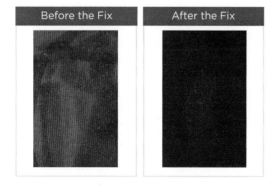

Make a Distinct Border

When you color adjacent areas with marker, wait until the first area is dry before coloring the area next to it. When you want a distinct border between the two, try using colored pencil to create it, since it won't dissolve in the Copic color. Outlining with a darker colored pencil can create a watercolor-like effect.

Make Gradations Smooth

When you try to create a gradation but it looks bad—either the colors didn't mix well, or the paper wasn't suitable for mixing—you can use colored pencil to smooth the transition. If you don't have the right color in your colored pencils, choose the pencil color that most closely matches the darker color and layer lightly.

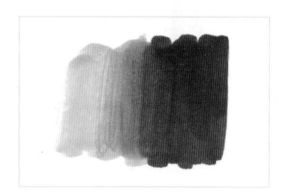

Before the Fix | After the Fix

Correct Uneven Color

Colored pencils can also be layered over Copic marker to correct unevenness and hide brushstrokes or streaks. Be careful not to get too dark. Going over colored marker with lighter colored pencils can have a lightening effect. Layering pencil color that is different from the marker color can add depth to the color.

Using Opaque White

Applying opaque white, in pen or liquid form, can fix mistakes and improve the finish of your illustrations.

Types of White

Copic does not have a white marker. If you want to express white other than the white of your paper, use opaque white. It comes in various forms, including liquid you can brush on, correction fluid, or white gel ink ballpoint pen. You can brush on sharp highlights with thin lines, or use it to make minor adjustments. Gel ink ballpoint pen is also useful for adding highlights.

Add white at the end

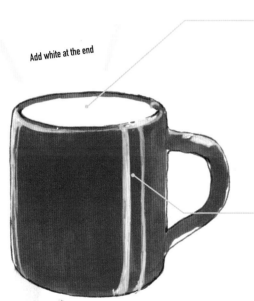

Erase the Overrun

You can make corrections using white where color has run over an edge. The correction can stand out, so it's best to add white to the entire area you intended to be white.

Add Highlights

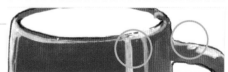

After coloring with Copic, adding highlights sparingly with opaque white will give a nice finish to your illustration.

TIP **Avoid adding color on top of white**

Any area where you add marker after coloring it with white will look lighter because of the white. It's best to wait and apply white when finishing an illustration. However, one technique is to take advantage of the effect to create a pale color.

OTHER TOOLS & MATERIALS

When coloring with Copic markers, it's important to consider the paper and other drawing materials you plan to use.

Choosing a Drawing Pen

When coloring with Copic markers, draw the main lines of your illustration with a pen that won't smear once color is added.

Doesn't Smear

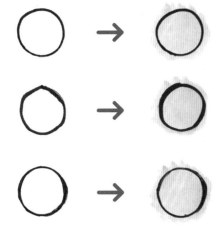

Copic Multiliner
Pigment-based and waterproof, this ink pen is highly compatible (won't bleed) with Copic markers. Available in 10 colors and a variety of line widths.

Copic Gasenfude Brush Pen
This pen uses the same ink as the Copic Multiliner, but has a brush tip suitable for a variety of effects, from drybrush to super-fine detail work.

Waterproof Pen
Waterproof pens using pigment ink should not smear when Copic colors are added, as long as the drawn pen lines dry completely first.

Smears Easily

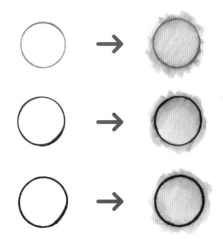

Graphite Pencil
Pencil is essentially powder on paper. Applying Copic markers over graphite will dissolve pencil lines, but not entirely.

Ballpoint Pen
Oil-based ballpoint pens dissolve into alcohol-based markers and smear, but not necessarily into pigment-based markers. Test beforehand.

Oil-Based Pen
Oil-based ink pens of any kind dissolve into alcohol and smear, making them unsuitable for drawing main lines.

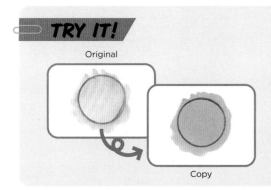

TRY IT!

Original

Copy

Copy before adding colors
Make photocopies of your original drawing before adding color. Then you can test out different color possibilities on the copies without ruining the original. You can also start over on another copy if you make mistakes while coloring. Bonus: If you made your illustration using a pen or pencil with smear potential, Copic markers won't dissolve photocopied lines, unless you are using an inkjet printer rather than a standard photocopier (see page 30).

More About Copic Multiliners

This is a pigment-based ink pen, bleed-proof and waterproof, that won't smear when used with Copic markers. It comes in 10 colors (including lavender, not shown) and various nib sizes, from 0.03 mm to 1.0 mm. You can switch out the pens according to the style of your illustrations.

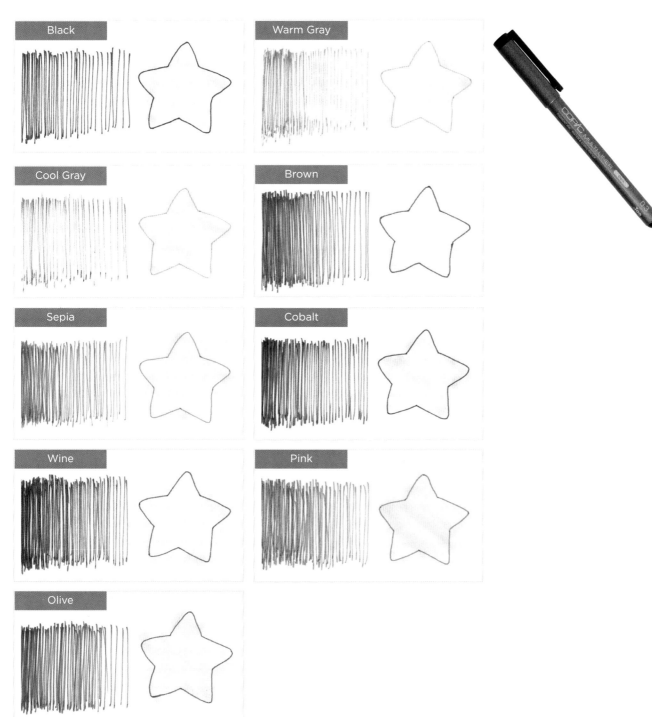

Selecting Paper

The paper you draw on will affect the look of your illustrations. Let's review the pros and cons of the most common options.

Smooth or Textured?

Smooth paper, such as photocopier paper, is easier to draw on. A textured surface like rough watercolor paper is harder to draw on, but adds interesting texture to illustrations.

Bond paper is super-smooth, making it easy to draw on. Copic's slightly off-white, medium-weight bond paper absorbs ink very well, and is suitable for gradation and blending. However, its nature makes it susceptible to uneven color, so add color slowly and carefully.

How Markers React to Paper

Different papers absorb color differently. Gradation techniques, your ability to blend, and the evenness of applied color will all be affected by the type of paper you choose.

Pen runs smoothly and color applies evenly on most sketchbook papers, but some absorb color so well that they use up ink quickly. Applied colors may look dark or bleed through thinner sheets. Be aware that the texture on the front of a page often differs from the back, making only the front side suitable for use.

TRY IT! Keeping color inside the lines

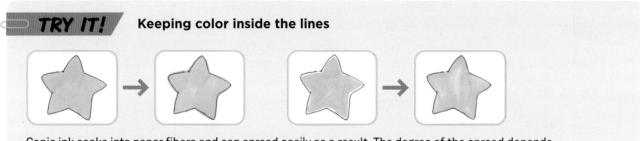

Copic ink soaks into paper fibers and can spread easily as a result. The degree of the spread depends on both the nature of paper and the quantity of the ink applied. Color slightly inside your lines, leaving just a little space, so that any ink spread will meet the line instead of bleeding beyond it.

TIP Protect your desktop from stains

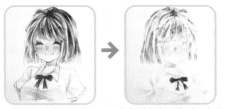

Colored drawing Color bled to the back side

Copic ink can bleed through thin paper easily, which may stain your work surface. Place a few pieces of scrap paper between your drawing and your desktop to prevent this. The scrap paper will also protect your illustrations from a dirty work surface.

Photocopier Paper

Marker Paper & Watercolor Paper

Photocopier paper is widely available. Coloring small areas is a challenge since the ink tends to smear, but colors mix well on it. The paper is usually bright white and comes in many kinds, some which might not absorb ink as well as others, and may not be suitable for gradation.

Marker paper is typically bleed-resistant and very smooth, and its slightly heavier weight makes it more durable. Watercolor paper is thicker as well and absorbs a lot of ink. It can be either smooth or rough in texture, depending on the look you want for your illustrations.

TRY IT! Test how colors will look when dry

Copic color tends to lighten when it dries, as the alcohol in the ink evaporates. Also, the ink absorbs differently depending on the paper, affecting the darkness of the dried color. Lighter colors in general, like the green shown, tend to change the most. Test out colors on the paper you plan to use to preview how they'll look once dry.

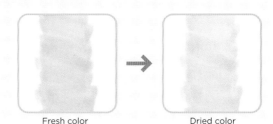

Fresh color Dried color

USING COPIC MARKERS TO CREATE ART

Selecting Colors

Color is often about personal preference, but these suggestions may help you make better choices for common subjects. Throughout the book, you'll also find color suggestions from the artists who created the illustrations.

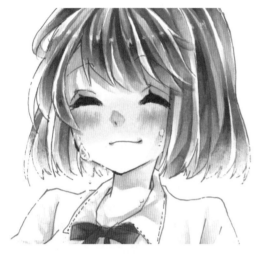

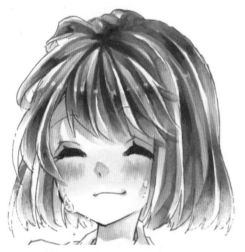

For Skin

- ☐ E50
- ☐ R00
- ☐ YR01

For skin tones, colors from the E (earth colors), R (red) and YR (yellow-red/orange) series are recommended. Use R series to draw reddish skin, and YR series to draw beige skin. Colors in the E series vary widely and are more independent of one another, lacking the continuity found in other series. Use them when you want to create colors that are neither R nor YR series. See page 36 for more color suggestions for creating skin tones.

For Dark Hair

- ☐ N-2
- ☐ N-4
- ☐ N-6

Express black hair using layers of gray, not black. Layers of color can create dark colors that are more expressive. There are four families of grays: C (cool), N (natural), T (toner) and W (warm). For beginners, cool (bluish) or natural grays are recommended. The differences between consecutive shades (numbers) in a series can be very subtle. Use three shades for black hair, but skip a shade or two in between for a difference that's detectable.

For Bright Clothes

- ☐ Y00
- ☐ Y02
- ☐ Y06
- ☐ Y08
- ☐ Y17
- ☐ YG41

When coloring single-color items such as clothing, choose colors within the same color family, skipping numbers between shades. For this yellow apron, use Y02 for the lightest yellow, Y06 for the medium yellow, and Y08 for the darkest (the shading). Use Y00 to blend any soft transitions between colors. Also, apply an accent color from a different series (in this example, YG41) to add depth to the illustration.

For Water or Sky

- ☐ BG000
- ☐ B02
- ☐ E000
- ☐ W-1

When coloring blue subjects such as the sea or sky, use B (blue) as a base, and add BG (blue-green) for greater dimension and depth. Also, use colors with smaller numbers to layer colors, for more clarity in your illustrations. Use W (warm gray) for any shadows in the water, for a natural finish.

For Flowers

- ☐ R000
- ☐ R02
- ☐ R14
- ☐ R37
- ☐ YG03
- ☐ G20
- ☐ G21
- ☐ G94
- ☐ E04

Choose from the R (red) series for the main color of a red flower. Choose a YR (yellow-red) for an orange one, and a RV (red-violet) for a pink one. For a more dimensional look and variety within the petals, add markers labeled with small numbers (R02, for example) for lighter, brighter colors, and bigger numbers (such as R37) for darker, less intense shades.

TIP Organize and plan ahead

Copic colors are organized by color family (series), then more specifically by their intensity (brightness or dullness) and value (lightness or darkness). Picturing the series in a color wheel as shown will help you select colors that go well together. When picking main colors, also grab a few lighter and darker shades in that color for a range. Darks should be in the 3-to-5 range to be effective.

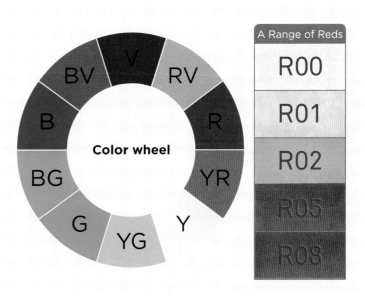

MARIPORI

About the Artist

Maripori loves drawing girls and other cute stuff using Copic markers. She enjoys participating in illustration exhibitions and events. Find her on Instagram @pppppppori.

Materials

Winsor & Newton Cotman watercolor paper, Copic markers, Copic Multiliners in cobalt, lavender, olive, pink, sepia, and wine, white gel pen, red and yellow ballpoint pens (such as Uni Style Fit), fluorescent pink colored pencil, and opaque white

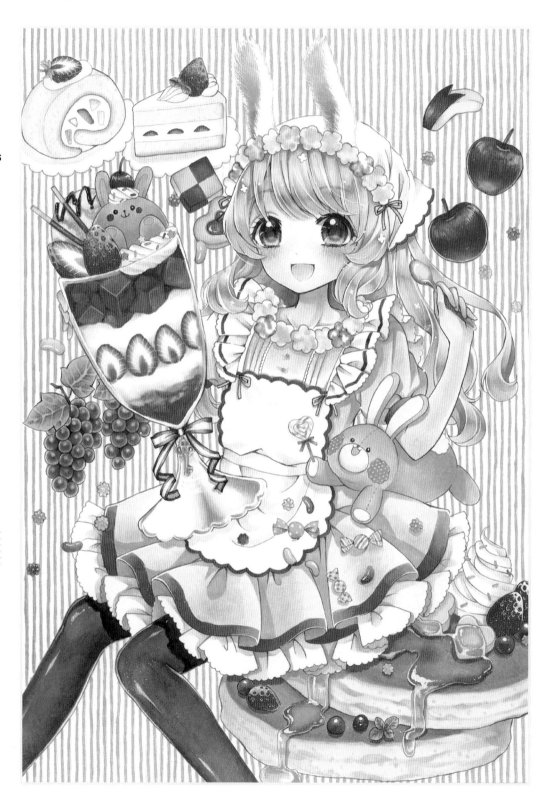

Change the Line Color for Each Item

Use pink Copic Multiliner to outline this character's rabbit-like eyes.

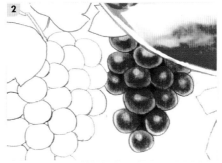

Outline the red grapes with wine Copic Multiliner, the blue grapes with lavender and the leaves with olive.

Use a red ballpoint pen to define the corners of the eyes. Pens that aren't alcohol-resistant should only be used for finishing details, as their ink may become smeared by Copic markers.

Use an outline color that is similar to the fill color in order to maintain the soft shape of transparent liquids, like the maple syrup pictured here.

From Start to Finish

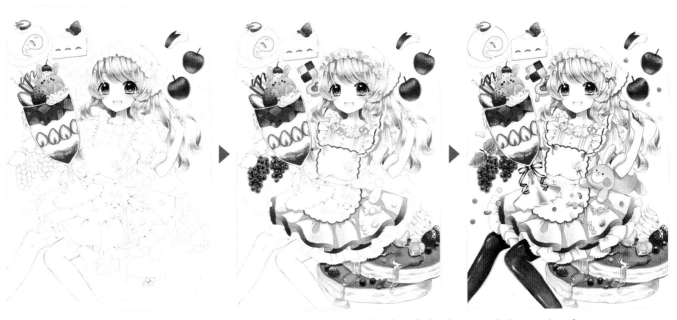

I started with the face and hair. After coloring to some extent, I looked at the whole picture and chose colors for the food around her head, the pancakes and her clothing. Next, I colored her tights and stuffed animal (a rabbit). Since red is used so much throughout, I chose blue for the ribbons of her dress and parfait. Finally, I made the tiniest treats brightly colored in order to make them pop out in the overall illustration.

ANALOG > DIGITAL

Converting Your Line Drawings to Digital

If you digitize your original line drawings, you'll always have a backup available in case you make mistakes while coloring. Instead of starting the drawing over from scratch, you can simply print out a new copy. Follow the tips below to successfully digitize your original line drawings.

1 Scan

Use a scanner to digitize line drawings done on paper. Make sure to use the appropriate color settings and resolution so you'll be able to make adjustments to your artwork using photo editing software. As a general rule, you'll want to select 24 bit color for the image type and 300 dpi for the resolution. When it comes to resolution, the higher the number, the better the quality—just remember that the file size will increase accordingly.

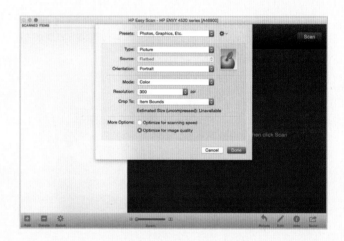

2 Use Photo Editing Software

Next, you'll need to make a few adjustments so that the digital version matches the original drawing. Adobe Photoshop is used for the examples in this book. Other photo editing software and apps have similar features, so you can use the same principles.

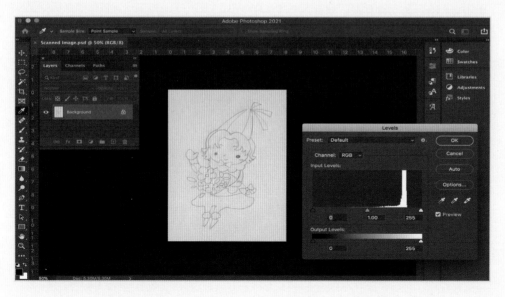

Levels Adjustment

Use the levels adjustment feature to adjust the brightness or contrast. Move the sliders to adjust the background paper to white and darken the faded lines to black.

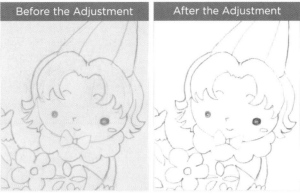

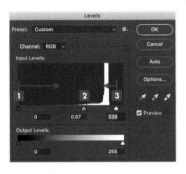

1 Shadow: the darkest point

2 Gamma: the middle point

3 Highlight: the brightest point

Eraser Tool

Zoom in to enlarge the drawing. Use the eraser tool to erase any stray lines, eraser marks, or visible dust.

Every drawing has mistakes or extra lines. Check thoroughly!

Brush Tool

Use the brush tool to fix any faded lines or lines that were accidentally erased.

Don't worry if some of the lines become faded when you use the eraser tool to clean up the image. You can fill them in using the brush tool.

Printing Out Your Art

Once you digitize your line drawings, you can print out multiple copies and add color. By printing out multiple copies, you can test out different color combinations and practice using Copic markers without worrying about making a mistake. The following guide includes some important information about printing out your art to use with Copic markers.

Inkjet Printers

Just like some pens may smear when used with Copic markers, certain printer inks are suitable for use with Copic, while others are not. If you have a printer at home, it's most likely an inkjet printer. The black ink in these printers is pigment ink, which means it's water-resistant and not likely to smear with Copic markers. The color inks in these printers are usually dye-based inks, which can be dissolved and smeared with Copic markers. Always test your individual printer with Copic markers just to be safe.

Laser Printers & Photocopiers

Copic markers will not smear lines printed on a laser printer or photocopier. This is because these devices use toner, which is a powder that fuses to the paper. Libraries and print shops usually have these devices and allow you to pay per copy. Just make sure to bring a flash drive with your artwork saved in a common file format, such as a JPG.

TIP

Photocopier ink does not smear

The name Copic comes from the fact that the markers do not smear photocopier ink. This means that you can make photocopies of your original drawings and practice coloring!

MANGA ARTISTS' COLORING TECHNIQUES

Learn how to color faces, hair, clothing and other details, guided by the artists who illustrated the six original characters featured in this book. Apply their tips and techniques to your own illustrations.

COLORING THE FACE & SKIN

A character's face is the first thing we notice. The character's appearance can change depending on the skin tone you choose and how you develop it.

HOW TO COLOR SKIN

Example 1

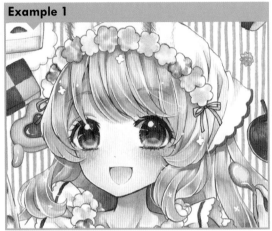

See the full illustration on page 26.

CREATING GLOW

Working variations of red into the skin color gives your character a warm, healthy look. Incorporate red into the shadows too, for added warmth.

Colors used

☐	RV00	☐	E000
☐	RV93	☐	E93
☐	E0000	Colored pencil: Neon pink	

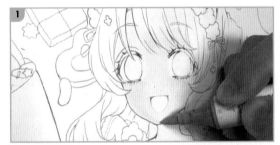

1 Color the entire face with base color E0000 and also the tips of the hair that fall into the face, for a transparent feel. Give it a reddish tone by adding E000 from the corners of the eyes to the cheeks, and blend with E0000.

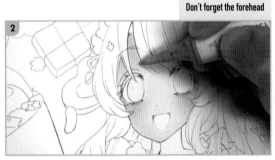

Don't forget the forehead

2 Add light redness to the cheeks, forehead and between the bangs, and blend with the skin using E000. Color the area above the eyes too, where the shadow of the hair will be.

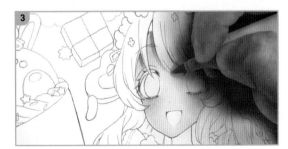

3 Add shadows to the face from the bangs and side hair. Color with RV93 and blend with E93. Your brushstrokes should follow the direction of the hair, from top to bottom.

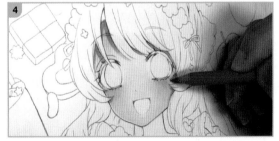

4 Add a bit more redness by drawing lines on the cheeks with neon pink colored pencil. Also add some RV00 on the cheeks to complete the character's healthy look.

Example 2

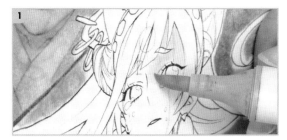

See the full illustration on page 126.

SHADING FOR SHAPE

To express the texture of the face and the shapes of its features, vary the pressure you place on the brush tip to create shade tones of the base color. You can also add shade by layering with other colors. Reflected light on the face also helps to reveal its form.

Colors used

☐ BV000	☐ R11
☐ V000	☐ YR000
☐ V01	☐ No. 0
☐ RV42	

Suggest the light source

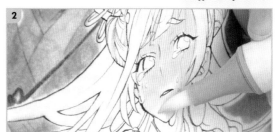

1

Color with YR000 as the base for the skin. The light source comes from below the face. Keeping that in mind, adjust your pressure on the brush tip to create shading that follows the form of the face.

2

Use No. 0 on the bottom third of the face, from the chin up, to create a gradation to white that indicates the light source. Then go over the area with YR000 again to strengthen the overall shading of the face.

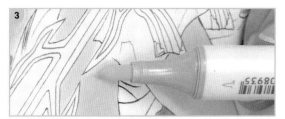

3

Color the neck, arms and legs with YR000 in the same way. When you color the legs, keep in mind the reflection from the water below, and leave a little more white (the white of the paper).

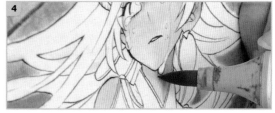

4

Using V000, add shadow on the top of the face and on the neck. Keep in mind the height of the forehead and eyelids, and increase the shade by adding BV000 or V01.

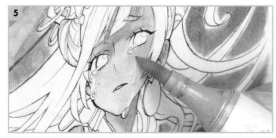

5

Add YR000 to dampen the cheeks slightly. Then color the darkest areas using RV42. Blend the color with R11 or YR000, creating the redness of the cheeks.

TIP **Add the shadows of the clothing**

When coloring shadows on skin, don't forget the shadows created by clothing. It's a small but important detail. Keep the size of the shadows in mind. For this illustration, use V01 to create gradation.

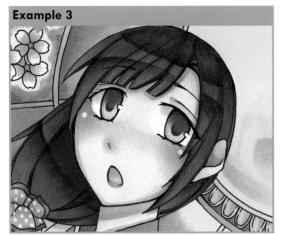

Example 3

See the full illustration on page 88.

BLENDING NATURALLY

How you blend the base color with the shadows and accent colors you add to the skin will determine how natural it looks. Be careful not to overblend, or you may lose the areas of light and shadow you've created.

Colors used

R20	E00
R32	E02
E000	White gel pen

1 Color the base of the skin using E000. Lay down the brush tip when coloring for more even coverage.

2 After coloring the base, add soft shadows using E00.

3 Add strong shadow with E02, and blend with E000 again. Don't overblend or you'll lose the shadow.

4 Add pink to the cheeks by coloring one-third of them with R32, then soften with R20.

TIP **Apply strong shadows on dry paper**

When adding strong shadows, wait until the previously applied layer is dry, so that the shadow doesn't blend with the wet color beneath it and become lost.

5 After softening with R20, blend the pink area with the base color of the skin. Layer E000 on top, and adjust the transition to look natural.

Don't add too much white

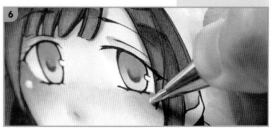

6 Finally, add white highlights where the pink is darkest on the cheeks. Don't add too much or it won't look balanced.

Example 4

See the full illustration on page 110.

INCREASING CONTRAST

For a more dramatic description of skin tone, don't cover the entire face with the base color, instead apply it only to the shadow areas. The nonexistence of color in the surrounding areas will create strong contrast.

Colors used

☐ YR0000 ☐ YR01
☐ YR000 ☐ No. 0

1

Color the shadows of the hair on the face with YR01 as a base color, then blend with YR000 and YR0000. Keep the head's roundness and the flow of the hair in mind.

TIP **Play up the contrast**

Adding color to the shadows only and not to the rest of the face creates clear contrast. You can soften the contrast if you decide you don't want it to look quite as dramatic.

2

For the nose, eye area, cheeks and chin, draw shadows with base color YR01, then layer YR000 and YR0000.

3

Color the hand with YR01, keeping the shape of the finger and the light source in mind, and blend with YR000 and YR0000.

4

Fix runaway color with No. 0

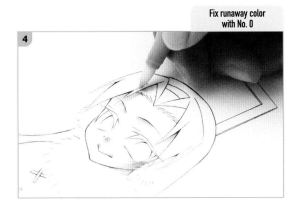

Finally, adjust the overall color of the shadow, and fix any color that crosses the line with No. 0. Notice how the roundness of the shadows adds cuteness to the character.

Creating Skin Tones

When selecting skin tones for your characters, use three different markers to create a base color, neutral color, and shadow color. The following guide includes suggestions for a variety of skin tones. The samples that follow show various combinations and how they look when layered.

Base Color ☐ E50

The base color you choose should be lighter than your finished image will be.

Neutral Color ☐ R00

This color should be relatively close to the base color and blendable with it.

Shadow Color ☐ YR01

The darkest color. When choosing your trio of colors, pick a combination that isn't too dark.

YR Series Base Colors

This lighter combination is suitable for a fair complexion.

☐ YR0000 ☐ E000 ☐ R01

This combination features a darker base and warmer neutral and shadows.

☐ YR20 ☐ R12 ☐ YR01

For a darker complexion, start with a darker base and add warm earth tones.

☐ YR21 ■ E35 ■ E39

R Series Base Colors

This reddish combination uses only R-series tones.

☐ R000 ☐ R00 ☐ R01

This combination is a gradation from red to brown.

☐ R000 ☐ YR01 ☐ E11

Start with a pink base color and add dark earth tones.

☐ R12 ■ E25 ■ E29

E Series Base Colors

The neutral color is more brown in this combination.

| E000 | E21 | E01 |

This combination uses a more yellow base color.

| E50 | E01 | E11 |

Use a gray from the W series for shading on warm colors.

| E01 | W-2 | W-3 |

A light base with darker browns creates a tanned tone.

| E50 | E13 | E35 |

This golden combination creates a warm skin tone.

| E30 | E55 | E57 |

This combination includes rich, warm tones for the neutral and shadow colors.

| E13 | E15 | E19 |

A brighter base can be paired with cool browns.

| E43 | E44 | E77 |

Start with a warm brown for the base, then add cooler browns.

| E57 | E47 | E49 |

Purple makes good shadows when brown is the base color.

| E35 | E37 | RV69 |

HOW TO COLOR EYES

Example 1

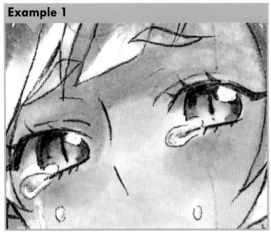

See the full illustration on page 126.

CREATING TRANSPARENT COLOR

Apply gradation to the irises to express clear eyes. Color the pupils with a single color, and add a white highlight over each eye to suggest roundness.

Colors used

	BV01		B000
	BV31		B23
	Y02		B37
	YG11		Opaque white

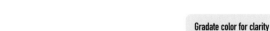
Gradate color for clarity

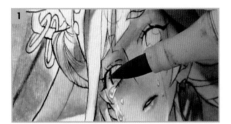

As a guide for gradation in the eyes, add the shadow on the white of the eyeball with BV31.

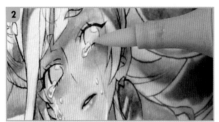

Color each iris. As a base color, color the top two-thirds with B000, and the bottom third with Y02.

Using gradation, color the top part of the iris with BV01, and connect it to the base color B000.

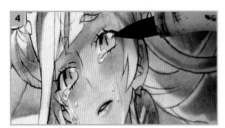

Color the top two-thirds of the iris with B37 and the bottom third with B23 and BV01 to create gradation. Add each pupil with B37.

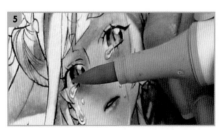

Use YG11 to create a space between the white of the eye and the shadow drawn with BV31.

TIP

Choose colors that relate

The detail color on the whites of the eyes (YG11) is repeated in the fluorescent color of the character's dagger. This shows that the light of the dagger is reflected in her eyes. When choosing colors, consider their relationship to the overall illustration to make it convincing.

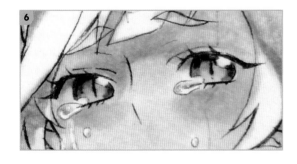

Review the eyes and keep adding color until they look finished. This time, light colored areas are layered several times.

Example 2

See the full illustration on page 88.

WORKING FROM DARK TO LIGHT

Layer color from darkest to lightest when creating same-tone gradation. This method tends to prevent the overall color from becoming too dark, compared to working from light to dark.

Colors used

☐ BG01	■ B28
☐ B000	☐ C-1
☐ B24	☐ C-3

1

Color with the light tone B000 as a base color for the eyes. Add B24 next, then BG01, from the top down to create gradation.

TIP Finish blending with lightest color

With same-tone gradation, re-apply the lightest base color at the end, for a well-blended finish. Here, B000 was applied again after B24 and BG01.

2

After the gradation has dried fully, draw the pupils in a crescent shape with B28. If you add this layer while the paper is still wet, the ink may smear.

3

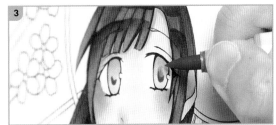

Add color to the pupils with B24, blending to make a circle shape.

4

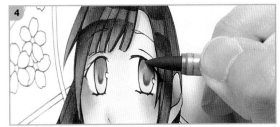

After adjusting the eye color with B24, soften the crescent shape with B28, and then soften the edge of B24 using BG01.

5

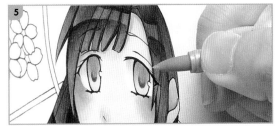

Finally, finish the whites of the eyes using gradation. Color the shadow below the top eyelid with C-3, then blend with C-1 from the top down.

Example 3

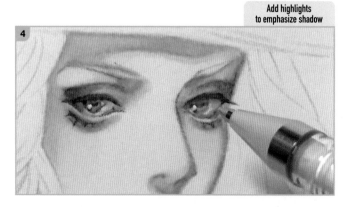

See the full illustration on page 70.

INCORPORATING MANY COLORS

Keep colors light to create transparency. Making shadows colorful keeps them from appearing flat, creating a more three-dimensional look.

Colors used

BV11	G21	T-2
BV31	BG01	White gel pen
V01	B60	Colored pencils:
R11	E34	Reddish brown and navy
Y000	T-1	

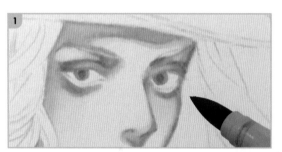

1 First, place the general color and use it as a base for developing a three-dimensional, transparent look. Color the irises with G21 and the pupils with E34.

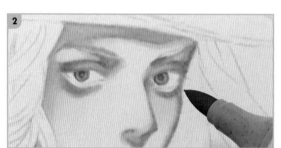

2 Blend the iris with Y000 to create some transparency. Then outline with BG01 or reddish brown colored pencil to add sharpness to the whole.

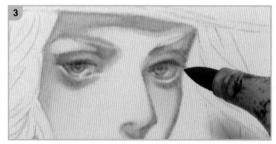

3 To add shadow, layer gray with T-1 and T-2, then blue with B60. Add shadow to the entire eye to express the roundness.

TIP Vary colors to strengthen features

Color the eyelash area with BV11 and BV31, and the rim inside the lower eyelid with R11. The use of different colors adds strength to the eyes overall.

Add highlights to emphasize shadow

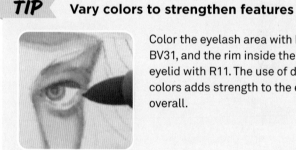

4 Add eyelash details with colored pencils, and layer R11 and V01 on the eyelids. Emphasize the shadow and roundness of the eyes by adding highlights with white pen.

Example 4

See the full illustration on page 52.

USING LIMITED COLOR

These eyes are red, but the changes in tone from the top to the bottom create a realistic roundness.

Colors used

RV32		R37	
RV69		E04	
R000		White gel pen	
R02			
R14			

Use the point to avoid smearing

1

Color the top half of the iris with RV32 and blend the bottom half with R000. Use just the point of the brush tip to prevent smearing.

2

Color the eyelid while waiting for the iris to dry. Blend from the center out, in R37 > R14 > R02 order.

3

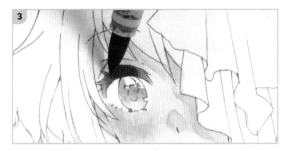

Apply RV69 on the center of the eyelid, and blend with E04. The smallest eyelash is so detailed that you may want to add it with pen.

4

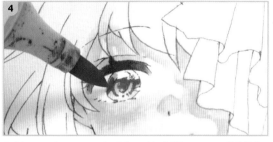

Add roundness to the iris with R37 on top of RV32. Red tends to spread, so color inside the line.

TIP **Take advantage of red**

Red smears easily. When you blend the color, draw as if you are showing the base color.

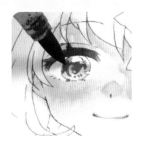

5

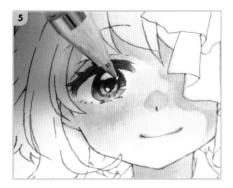

Fill in the rest of the top half of the iris with RV69, and blend with E04 using the point of the brush tip. Then add highlights using white pen. The white used here shows the base color, so the white area is not colored from the start.

HOW TO COLOR HAIR

Example 1

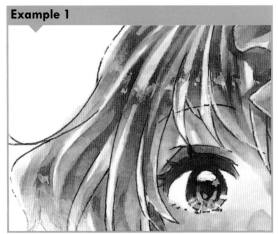

See the full illustration on page 52.

BUILDING HIGHLIGHTS

Start by placing the yellow highlight first, then add the base color later. Using this method, you can create soft brightness and warmth. Make sure your strokes follow the direction of the hair for a realistic look.

Colors used

RV32		R85	
R000		Y000	
R30		Y23	

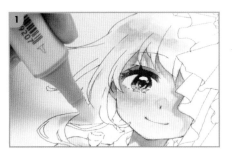

Apply Y23 along the hairline to create a highlight area and blend with Y000. You don't need to blend fully.

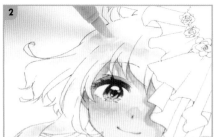

Before the highlights dry, color entire hair with R000. Don't worry if the color is uneven or goes over the lines.

Color the hair at the top of her head and add some shading to the rest using R30, following the hair's direction and applying some strokes over the highlight area.

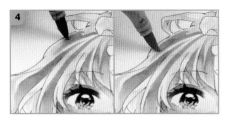

Develop the shading by applying darker strokes with RV32 at the top of the head, building upon the previous lighter strokes. Apply more R30 toward the hair tips.

Save the shadow of the hat for last

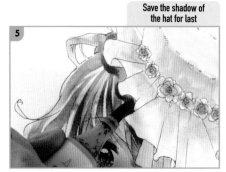

Add the shadow of the hat on the hair. Color the top with RV32 and the bottom with R30. Next, add R85, and soften with RV32, and then R30.

TIP **Emphasize the highlights**

Apply R85 under the highlights on the hair to emphasize them.

Example 2

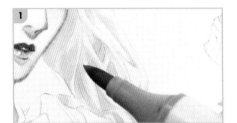

See the full illustration on page 70.

ADDING SHADOWS

By taking advantage of shadows and their placement and color, you can create different hairstyles and add movement to the whole illustration. Keep a three-dimensional look in mind as you work.

Colors used

☐ BV20	☐ BG000	☐ N-2
☐ V000	☐ B60	☐ T-1
☐ V01	☐ E0000	☐ T-2
☐ Y0000	☐ E000	☐ T-3
☐ BG0000	☐ E40	☐ W-0

Unify the illustration

1

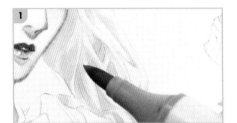

Color the hair generally with W-0, then layer E0000 and E40 to begin creating depth.

2

Add blue with BG0000. This color is also used in the skin, so repeating it in the hair helps to unify the illustration.

3

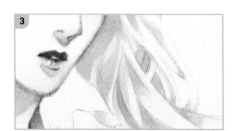

Color the area bordering the face with BG000, creating more unity. Deepen the shadow with B60 for a more three-dimensional look.

4

Layer N-2 gray on the undersides of the hair, continuing to add depth.

5

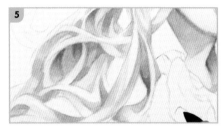

Add beige with E000 for the top sides of the curls. Deepen the shadows with T-1 and T-2, and emphasize the flow by outlining the hair.

6

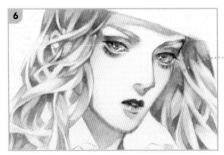

Add bluish shadow with BV20 on the area where the hair meets the skin to finish.

TIP

Add eye-catching color

Add Y0000 yellow and purples V000 and V01 on the hair bordering the face. These colors will be too much to use all over the hair, but using them in this area will call extra attention to it.

Example 3

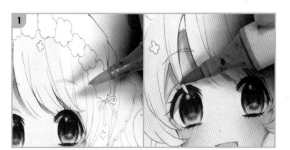

See the full illustration on page 26.

LAYERING COLORS

For shiny hair, layer colors in the details. The key is to extend the colors vertically along the direction of the hair. Add highlights to separate sections.

Colors used

☐	RV00	▦	E33
☐	YR31	☐	E50
▦	Y26		White gel pen

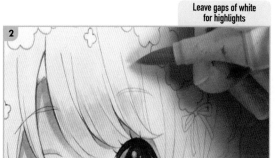

Leave gaps of white for highlights

1 Color the entire hair with E50. Color the hair tips with RV00 and blend with the base color using E50.

2 Color the shiny area vertically with YR31. Leave gaps between the sections of hair for highlights.

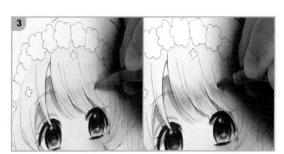

3 Blend the shiny YR31 area vertically with E50. Apply Y26 on top in a smaller area and blend with YR31.

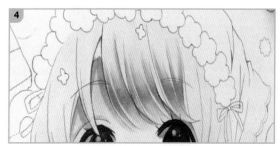

4 Apply E33 in a smaller area than the area colored with Y26 in the previous step, and blend with Y26.

5 Add the shadow of the floral decorations on the hair. Color with YR31 toward the bottom and blend with E50.

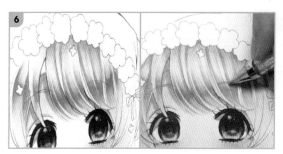

6 Deepen the shadow with Y26 to define the hair sections, and blend with YR31. Add highlights between the sections of hair using white pen.

Example 4

See the full illustration on page 110.

SIMPLIFYING COLOR

Try coloring simply without using many colors. Take advantage of the area without color to create contrast and sharpness. When coloring, make sure your brushstrokes follow the flow of the hair.

Colors used
- Y11
- Y32
- No. 0

Use limited color
to simplify

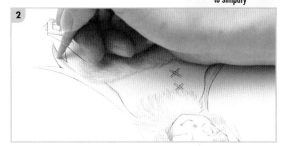

1

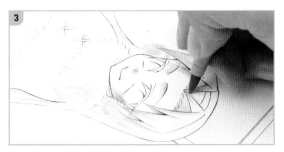

Color the dark shadow areas with Y32. Draw fine lines and keep the flow of the hair in mind.

2

Soften the Y32 by adding Y11. No other tone is added, just the original color of the pen.

3

Soften the part. Color the shadow area with darker Y32, then make it lighter with light Y11.

4

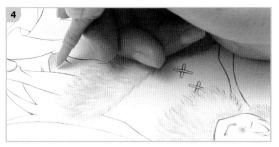

The hair behind the back is in the shadow, so there are no white highlights there. Color the shadow with Y32, and blend with Y11 for the whole area.

5

Color the hair at the roots in the order of Y32 then Y11, without going beyond the lines.

6

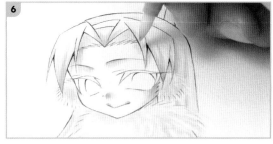

Fix any smeared areas with No. 0. Be careful not to erase the other areas as you do so.

HOW TO COLOR LIPS

Example 1

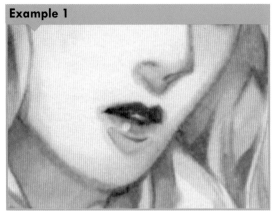

See the full illustration on page 70.

LAYERING FOR FULLNESS

For a fuller lip, layer colors and create a tone that matches the expression. Add shadow to bring out the tone, and express a glossy look by adding highlights last.

Colors used

BV20		No. 0	
R11		White gel pen	
R20		Colored pencils: Reddish	
R81		brown and navy	

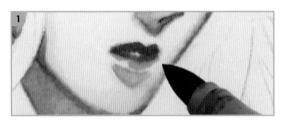

Outline the upper lip clearly, using BV20. Color the lower lip using R20, R11 and R81, except for where the highlight will go. Layer colors on both lips to create the right tone.

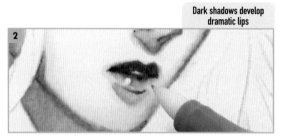

Dark shadows develop dramatic lips

Add contrasting dark shadow to the corners of the mouth using reddish brown or navy colored pencil. Place the highlight on the lower lip with white pen and blend the lower lip using No. 0 to finish.

Example 2

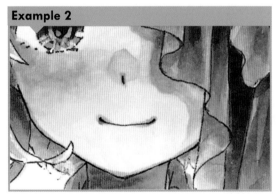

See the full illustration on page 52.

MAKING A SIMPLE MOUTH

A simpler closed mouth still needs some color to look nice, in the form of shadow added to the corners of the mouth.

Color used

R01	

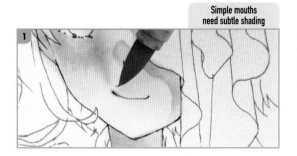

Simple mouths need subtle shading

Use R01 to add shadow to the corners of the closed mouth. Shadows can also be placed to support various facial expressions.

Example 3

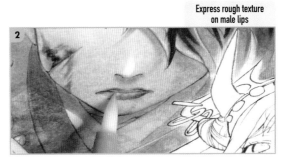

See the full illustration on page 126.

MATCHING TO THE CHARACTER

Color lips differently depending on the character. Generally, give female lips a cute look with red-tone gradation, and express rougher texture on male lips using highlights.

Colors used

▨	RV42	▨	E93
▨	RV52	☐	No. 0
☐	RV91		White gel pen
▨	RV93		

1

Color the male's lips using RV91 as a base. Then, using RV93 for the shadow color, layer the color as if you're drawing vertical wrinkles on the lips.

2 Express rough texture on male lips

Create contrast by using No. 0 to remove much of the RV91 and RV93 from the previous step, creating a highlight while leaving a hint of roughness.

1

Color the female's lips with RV42 from the center toward the edge, then with RV52 from the edge toward the center, to create gradation. Then layer E93 on the center to increase the redness.

2

Color the highlight areas with No. 0 and blend a little. This character doesn't wear lipstick, so the lip color should look natural.

3

Add highlights with white pen. After the ink dries fully, adjust the shape by shaving the white with a razor blade to complete. A male's lips don't need gloss, so white pen was not used in the previous example.

TIP

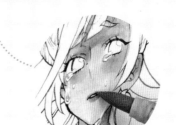

Red adds character

Adding more red on the center of the lips creates a cute look and also makes the surrounding skin look more transparent. Redder lips can also signify health or sexiness.

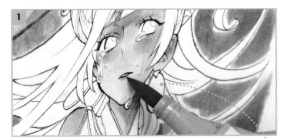
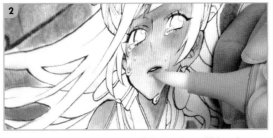

Example 1

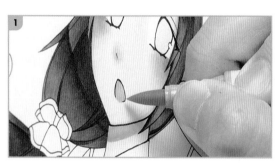

See the full illustration on page 88.

SHADING AN OPEN MOUTH

Use gradation when coloring the mouth, to create depth. The lower lip is made with a smooth line of color, applied in the same way you would apply lipstick, from left to right.

Colors used

	RV000
	R20
	R32

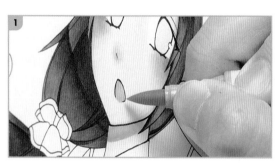

1

Start with the inside of the mouth. Use R20 to apply the base color, carefully staying within the mouth area.

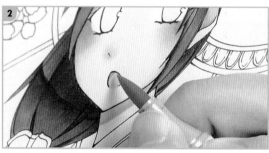

2

After coloring the base, add the shadow by layering R32 on the top.

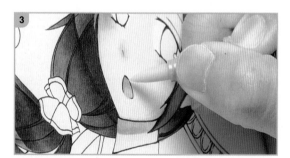

3

After adding the shadow, color with R20, then RV000, in gradation. This completes the inside of the mouth.

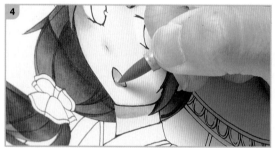

4

Outline the lower lip with a thin line, using R32. Move the brush as if you were applying lipstick.

Don't overdo the lower lip

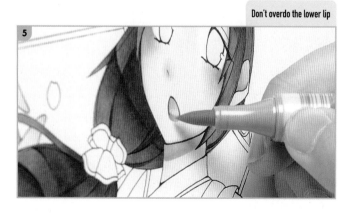

5

Layer R20 to complete the lip. Be careful not to smear the color, making the lip too big.

HOW TO COLOR SWEAT & TEARS

Example 1

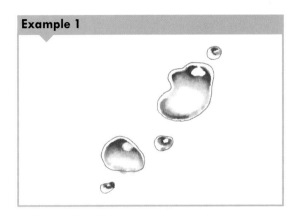

COLORING WATER DROPS

Color drops of water in a way that the color becomes darker from the center out, to express the light hitting the drops. For the darkest part, choose the darkest blue, to create a three-dimensional look.

Colors used

☐ B00		■ B29	
☐ B14		☐ No. 0	

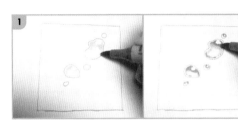

Color with B00, except for the center and the highlight of each drop. Then color around the highlight and under it with B14 narrower than B00, and blend with B00.

Soften the center

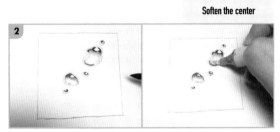

Color a narrower area with B29 and blend with B14. Soften the center of each drop with No. 0 and blend to complete.

Example 2

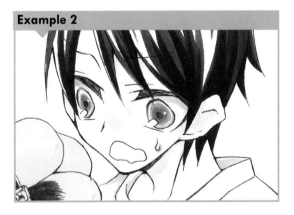

CONVEYING SWEAT

Drops of sweat are not colored, but the area immediately surrounding them is clear and emphasized. Also, the shadow of the sweat is darker than the skin, and adds texture.

Colors used

☐ YR000	
☐ YR01	

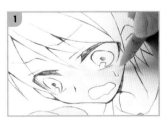

The skin base is colored with YR000. To emphasize the sweaty area, leave it without base color.

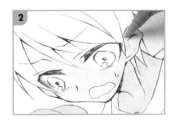

Layer YR000 to build up areas of shadow on the skin, emphasizing the still-white sweaty area.

Color sweat's shadow

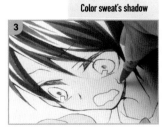

Add the shadow of the sweat drops with YR01, which is darker than the skin and gives dimension to the drops.

Example 3

See the full illustration on page 126.

COLORING FALLING TEARS

When coloring tears, don't color all the way to the outline. This will give the tears a transparent, three-dimensional look.

Colors used

☐ BV000
☐ YR000
☐ B000
▨ B63
Opaque white

1

Color the tears with a base color of B000. Don't add color along the outline of the tears. The remaining white makes it look like the tears blend into the skin.

2 | Reflect color in transparent tears

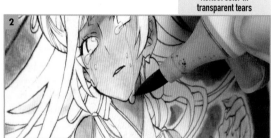

Reflect the shadow of the neck into the tears with BV000. Tears are naturally colorless, so reflecting the color behind the drop communicates transparency.

3

Color along the face outline with YR000 similarly, and have the tear reflect it. Then color with B63 to darken the drop's tone.

4

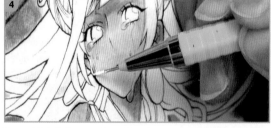

Draw highlights with white dots on the center of the raised area of each drop, using a sharp mechanical pencil point dipped in opaque white.

5

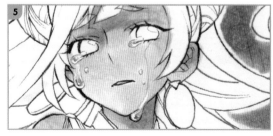

Adjust the centers by shaving the white with a razor blade, and touch up with B63 again to finish.

> *TIP* **Apply white with a pencil tip**
>
> When applying white for highlights, choose the best tool for the job. For tiny highlights, a white pen isn't dense enough and the tip is too thick. Instead, try a 0.5 mm mechanical pencil point dipped in opaque white.

Example 4

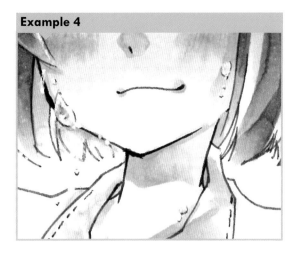

FORMING ROUNDER DROPS

Sometimes you may want a rounder look for tears or sweat droplets. After coloring them with white ballpoint pen, add Copic color for a three-dimensional look that has a slight transparency.

Colors used

☐ B41

White gel pen

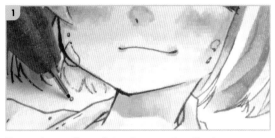

Draw the outline of the drops using Copic Multiliner. The three-dimensional look will be added later, but draw with a spherical shape in mind.

White then color for dimensional drops

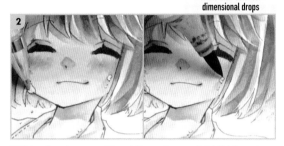

Fill in the drops with white gel pen. Add B41 on top of the pen ink, without blending. This creates the three-dimensional look.

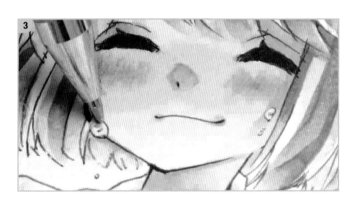

To emphasize the reflection of light on the drops, outline the inside of the line with gel pen. Adjust the overall color and highlights to finish.

TRY IT!

Find a carrying case

How many Copic markers would you take with you when going out to draw illustrations? There are hundreds of colors, making it difficult to choose. If you use a carrying case or pouch, you can bring as many as you want. Shop around and you'll find many types to choose from.

SUZU KAWANA

About the Artist

Suzu Kawana is a Tokyo native known for her colorful artwork using Copic markers. She excels at capturing and expressing the emotions of teenage girls. Find her on Instagram @spicaboy.

Materials

Copic markers, Copic Multiliner pens, colored pencils, white gel pen, design paper

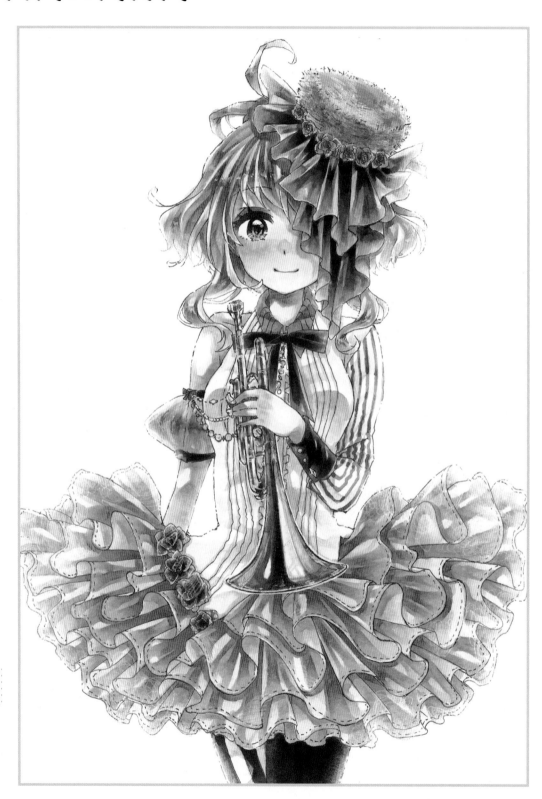

Combining Markers with Colored Pencils

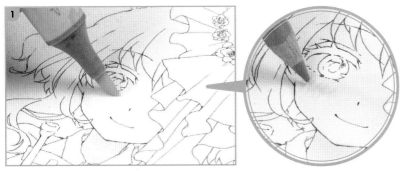

Color the skin with YR0000 as a base color, and layer E000 to create a three-dimensional look.

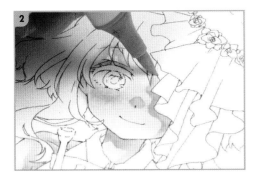

Color the shadow area with R01 as a base color. Layer E000 later to add darker shading.

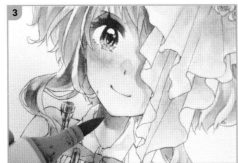

Color darker areas of the skin such as the neck with E11. If the color becomes too dark, lighten it with YR0000.

From Start to Finish

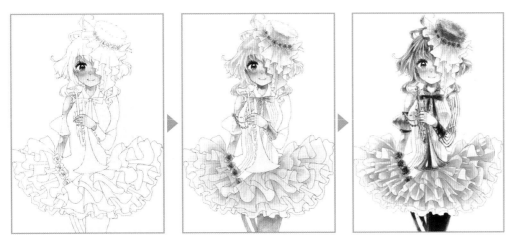

I started with the base color of the skin, then added one shade darker before moving to the next part of the illustration. This approach prevents overcoloring. After completing the majority of the coloring, I added the darkest shadows. When I feel like an illustration is complete, I like to use my phone to capture a snapshot and check the overall balance and clarity of the image.

ANALOG > DIGITAL

Processing Photos to Create Line Drawings

You can use photo editing software to convert photos into line drawings that look as if they were done by hand. This technique is useful for creating backgrounds for your characters.

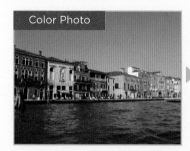
Color Photo

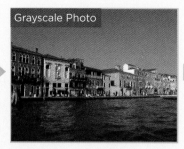
Grayscale Photo

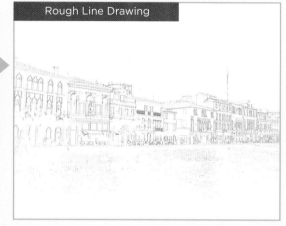
Rough Line Drawing

In this process, you'll start with a color photo, then convert it to grayscale. Then you'll extract the outline to create a rough line drawing.

① Convert the Photo to Grayscale

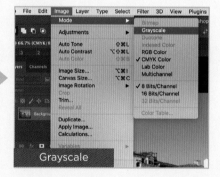

First, open the photo using Adobe Photoshop. Change the image mode to grayscale (black and white) by selecting Image > Mode > Grayscale.

TIP

Warning message

You may receive a pop-up message asking if you want to discard the color information. You'll need to confirm in order to complete the process. If you want to keep the original color version of the photo, just make sure it's saved under another file name.

② Extract the Line Drawing

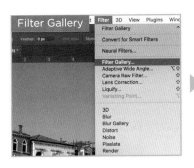

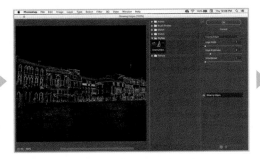

Next, you'll extract the outline of the object from the grayscale image by selecting Filter > Filter Gallery, then select Glowing Edges under the Stylize menu option. This will create a black and white mirror image of the photo. Adjust the Edge Width, Edge Brightness and Smoothness using the slider tabs. Finally, select Image > Adjustments > Invert to complete the rough line drawing.

TIP **Glowing edges adjustment**

We recommend the following settings for Glowing Edges, but you can adjust the numbers based on your desired line style.

Edge Width: 1 **Edge Brightness:** 3 **Smoothness:** 1

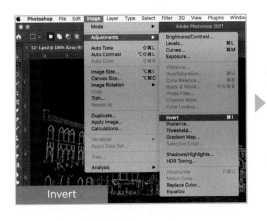

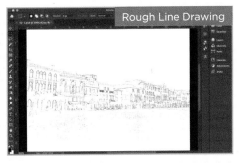

You can print out the image and trace the outline using a Copic Multiliner to create a hand-drawn background for your drawing, then have fun adding color using Copic markers.

TIP **Make additional adjustments**

If necessary, adjust the brightness and contrast of the line drawing until you achieve the desired result. Go to Image > Adjustments > Brightness/Contrast and move the slider tabs to make adjustments.

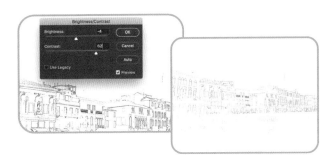

COLORING CLOTHES

SECTION 2

Characters' costumes are made from all different sorts of materials and display a variety of patterns. The coloring method you use and the way you add shadows to the fabric can change the impression a lot.

HOW TO COLOR FABRIC

Example 1

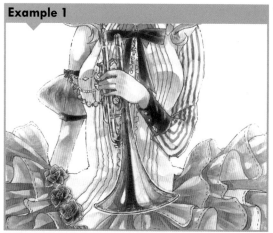

See the full illustration on page 52.

STRIPED FABRIC

Proceed carefully when adding stripes, since the pattern stands out. Draw them last after completing the rest of the outfit, otherwise they might get smudged. The lines should curve along the body's shape and change where the clothing wrinkles and folds.

Colors used

BV0000	R32	N-4
BV25	R85	W-2
R0000	N-1	Oil-based colored pencil:
R17	N-2	Reddish brown

1

Color the shirt's shadows with N-1, and gradually add BV0000 and R0000. Do not add shading to the entire shirt, but leave some white and lighter areas depending on the darkness of the shadows.

TIP Shadows first, then reflected color

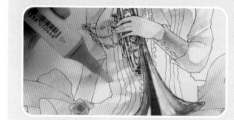

First add the main shadows of the clothing, then add the color reflected from other objects, such as the trumpet and her arms.

2

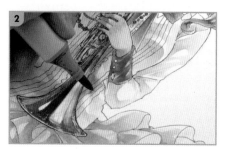

Apply W-2 for the areas of darkest shadow, and also for the shadows of surrounding objects that appear on the shirt.

3

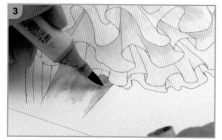

Color the base of the legs with N-2. Then add N-1 as you move down the legs, gradually making them lighter toward the bottom.

4

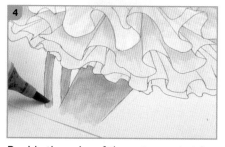

Decide the color of the outermost stripe by considering the balance between black and white. Choosing black here provides the best balance.

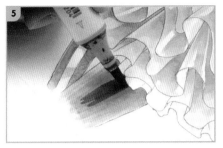

Add a shadow on the striped leg with N-1 the same way as on the shirt, then apply R17 down the middle of the solid leg, over the N-2 gray. Add it to the shadow of the skirt where you emphasize the center of gravity.

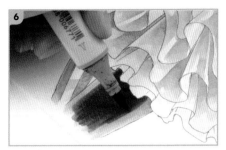

Add shading using N-4 on top of and beside the R17 red, keeping in mind the roundness of the leg.

Adjust the outer edges with N-2, and if the R17 becomes too dark, layer with N-4 to adjust. Color the shadow of the skirt with BV25. This shadow is plain, but it adds contrast.

Color the stripe pattern. First draft the lines roughly in oil-based colored pencil (reddish brown). The important thing is to have the lines follow the curves of the body and the wrinkles of the clothing.

TIP

Save the stripes for the end

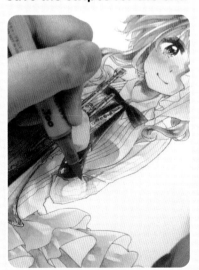

Add the stripes last. If you add the shadow of the shirt later, the color might smudge the lines.

Draw the final stripes using R32 along your colored pencil lines. Their thickness is up to you, but make sure they look realistic.

Be careful with the shadows

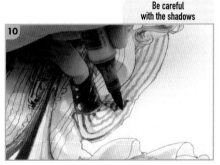

After the stripes are completely dry, add R85 as the shadow of the stripe pattern. Be careful not to draw the shadow thicker than the stripe.

Example 2

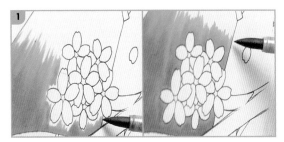

See the full illustration on page 88.

SOLID AND PATTERNED FABRIC

The character's kimono is solid green, but use yellow tones for gradation on the sleeves and also on the patterned apron, to reflect the color from the light glowing behind her and to create unity.

Colors used

☐ Y00		☐ YG00
☐ Y02		☐ YG06
☐ Y06		☐ YG41
☐ Y08		☐ G07
☐ Y17		☐ G17

1

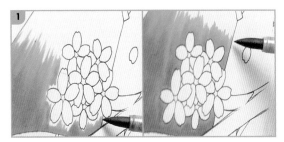

First, color the darkest part of the kimono using G17. Then color with G07 to create the base of the gradation that will flow from the bottom to the top.

2

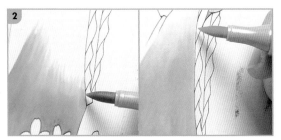

Color with YG06 to connect the flow to G07 from the previous step. Color with YG41 in the same way to create a smooth gradation.

3

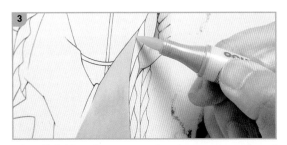

After finishing the green, color the green section of the kimono sleeve from top to bottom using YG00 in the end. Blend YG00 with YG41.

TIP Lay brush flat for even color

Be careful to avoid unevenness, since the area of gradation is wide. Lay your brush tip flat as you apply color.

4

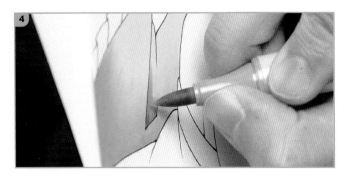

Add a shadow to the wrinkle of the kimono sleeve. First, color the darkest part using G07. Then use YG06 to blend the G07 into the surrounding area.

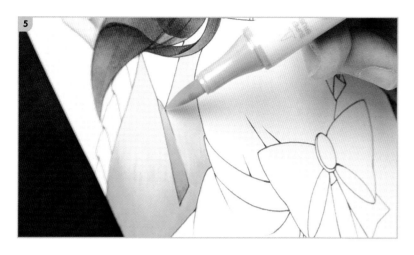

After you're done blending with G07, layer YG41 on top. Adjust the color as you check the balance to complete the kimono sleeve.

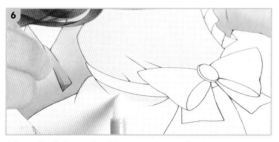

After the ink on the kimono sleeve is dry, start coloring the apron. First, apply the base color entirely with Y00, covering evenly.

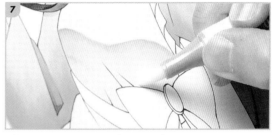

After the base ink is dry, add the shadow color. Add the darkest shadow at the bottom of the chest, and blend from the top to the bottom in the order of Y02 to Y06.

TIP Adjust the shadows

If the shadow is too pronounced after coloring Y02 and Y06, use Y08 and Y00 to soften it.

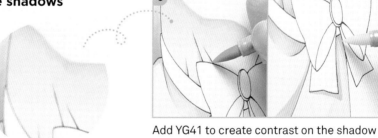

Add YG41 to create contrast on the shadow and fabric. Add shadow below the ribbon using Y08. Softly blend with Y00 to create realistic texture.

Use chisel tip for even lines

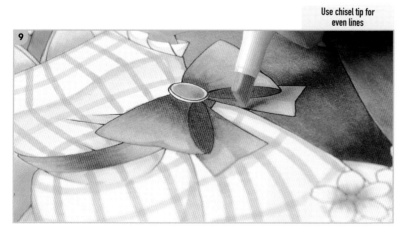

Add the apron's pattern last, with Y17 and Y08. Use the chisel tip to make even lines.

Example 3

See the full illustration on page 70.

WRINKLES AND RIBBON

This character's shirt is white but worn out and wrinkled, so we'll show that using color. The ruffled ribbon is shiny, creating a difference of texture.

Colors used

BV00	YR0000	T-0
BV31	B60	W-0
V01	E40	No. 0
V91	C-1	
R81	N-2	

B60 blends well with any color

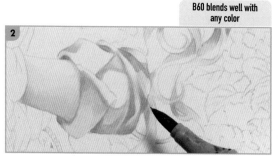

1 Color the general shape of the shirt using W-0, with cotton fabric in mind. Build a three-dimensional look by darkening areas with beige (E40) and gray (T-0).

2 Draw the wrinkles with C-1 and B60. B60 can blend with any color, so it is particularly useful for layering. Then create depth by adding strong shadows with N-2.

TIP Make white look worn

White shirts are not perfectly white, especially when they're worn out like this one. Use YR0000 to add yellow to the white to make it look worn.

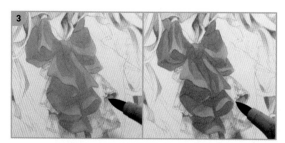

3 Color the ribbon with V01. First color the entire area, then layer V01 to add shading and create a three-dimensional look. Build details with BV31.

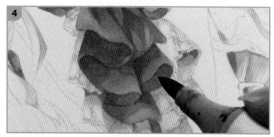

4 Develop the shading by layering V91 and R81 to blend with the BV31. V91 adds a dusty tone, creating an antique look.

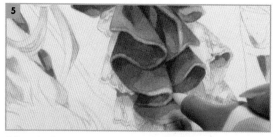

5 After darkening the shadows with N-2, trace the edges of the ribbon using No. 0. Use No. 0 to apply highlights that show the shine of the fabric.

See the full illustration on page 126.

TRANSPARENT FABRIC

When coloring fabric that you can see through, it's important to show what's under the layers. Leaving the edge of this dress without color will emphasize its shape while maintaining its transparent look.

Colors used

BV01	YR000	W-1
BV31	YG11	No. 0
RV11	B34	
RV19	B37	

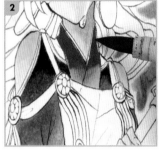

1 This dress has a gradation pattern that gets darker in the order of YG11 > BV01 > B34 > B37.

2 RV19 is used for the top half of the collar. The bottom half is colored using RV11, because of the light coming from below.

TIP Be aware of the light source

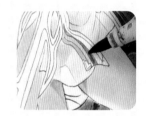

The bottom hem is colored similarly to the collar in step 2, getting lighter (more transparent) toward the light source.

3 The color of the part of the collar that we see behind the transparent fabric assumes a density of 20 percent. Color it lighter than the original color (RV19) using RV11.

4 Apply No. 0 to the undergarments, and color the skin with YR000 and the undergarments with BV31. Leave the edge of the white fabric colorless to emphasize its transparency.

5 The fabric appears whitest toward the center of the body. Blend the BV31 from the previous step using No. 0 to create gradation. Adjust the color as you check the balance.

Reflect colors in the shadow

6 Keep the colors of what is beneath and around the fabric in mind when coloring its shadows. Use BV01 as a base. YG11 and RV11 are reflected in the shadows.

HOW TO COLOR FUR

Example 1

See the full illustration on page 52.

SHORT AND FLUFFY

Make the fur texture on the black hat by layering with white. The lighter layers will show the thickness of the material and create fluffiness.

Colors used

N-6

White gel pen

Spread and press

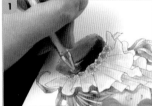

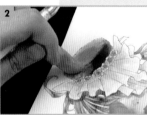

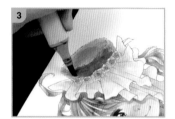

1 Add white gel pen along all sides of the hat, following the shape, without adding pressure to the pen tip.

2 Spread the white with your finger before it dries. Press as you leave fingerprints to create a fluffy look.

3 Add N-6 to the darkest area.

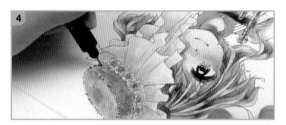

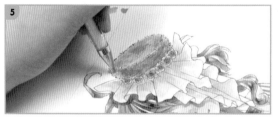

4 Repeat steps 1–3. Then add fur lines with the same pen used for the main lines (red, in this case), brushing from the inside out. Do this to form the edges of the hat also.

5 Trace with white to break up the fur lines drawn in the previous step, and to make the fur look soft and fluffy.

Example 2

See the full illustration on page 110.

LONG AND NATURAL

For longer fur, apply colors in layers of different sizes. Move the pen tip along the flow of the fur, but with some randomness in direction to create a natural-looking texture.

Colors used

E11
E33

The goal is to achieve a darker brown, so use E33 for the base color. Make small movements with the brush tip. Draw from the root of the hair outward.

Let layers dry before adding more

Layer E33 little by little, drying between layers. Repeat three times for a dimensional look. If you layer wet on wet, the individual layers and the hair flow will be lost.

Color lighter fur with E11. Leave the areas white where the light hits, to add contrast.

Layer E11 three times for a dimensional look. You can use a pen with low ink to create a thinned look.

TIP Aim for imperfection

If all of the hair flows perfectly in a single direction, it will look flat. Draw lines somewhat randomly.

SILKY AND SHINY

Example 3

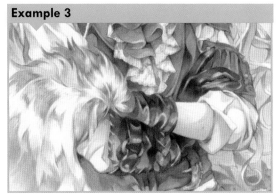

See the full illustration on page 70.

Add yellow to white fur to express shine. The tones are similar to the character's shirt color, creating unity. Also, simpler areas in the fur provide a nice contrast to the highly detailed areas in the rest of the illustration.

Colors used

YR0000	E40	W-1
Y0000	C-2	W-2
Y000	T-1	Colored pencil:
B60	T-2	Navy

Play up contrasts of light and dark

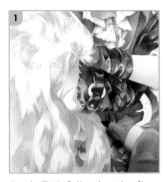

Apply E40, following the flow of the fur, and add bluish shadow with B60. Apply YR0000 to lighter areas, and add Y000.

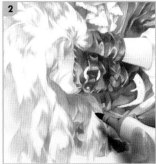

Add contrast on the fur using W-1. Emphasize the differences of light and dark with Y0000 yellow and W-2 gray.

Emphasize the outlines of the fur using C-2, T-1 and T-2. Leave some parts of the fur white, a nice rest for the eye in a very detailed drawing.

Example 1

See the full illustration on page 26.

RABBIT EARS

For soft, fluffy rabbit ears, draw the fur finely along the outline of the ears, in brushstrokes that extend from the inside out.

Colors used

R30	No. 0
R83	Opaque white
R85	Colored pencil: Red

Brush in the flow of the fur

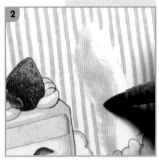

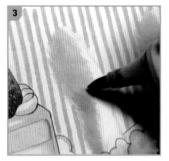

1 Draw the outlines lighter using colored pencil, as you imagine the direction of the fur.

2 Color the inside of the ear with R30, in brushstrokes that extend outward to create the flow of the fur.

3 Darken the lower inside of the ear. Color the flow of the fur with RV83 and blend with R30.

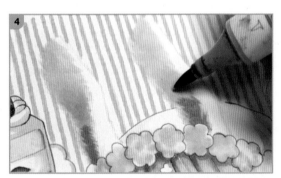

4 Darken the rest of the inside of the ear using R85 and blend with R83 to create gradation.

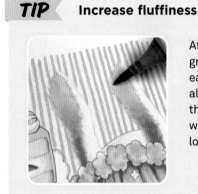

TIP Increase fluffiness

After finishing the gradation of the inner ear, add tiny lines along the outlines of the ear with R83. This will make the ears look fluffier.

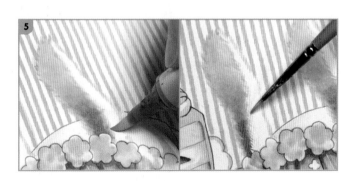

5 Soften all over with No. 0. Then, using a tiny brush, create the inner fur with opaque white.

HOW TO COLOR LEATHER

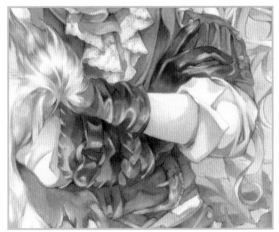

See the full illustration on page 70.

BLACK OR BROWN

Layering various colors over the base color establishes the leather's thickness and shine. By developing dark shadows with various colors, realistic texture and depth are created.

Colors used

BV23	E41	T-2
BV31	E42	T-4
V01	E43	W-1
R02	C-1	W-2
Y000	C-4	W-3
Y00	N-2	No. 0
B60	N-4	Colored pencil: Navy

1 For the brown leather, apply base colors E41 and E42. Add yellow with Y000 and Y00, and darken the color with W-1, W-2 and E43.

Don't color too dark

2 As you emphasize the shadow using W-3 and N-2, keep the entire look from becoming too dark by applying blues B60 and BV31, and purple V01.

3 Add shadow using BV23 and T-2, and blend the entire area. Then, emphasize the brightness using navy colored pencil.

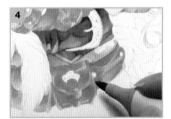

4 For the black leather, apply W-1 for the base and add shading with T-2 and C-1. As you color, keep shine in mind.

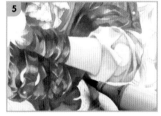

5 Layer in the order of N-2, C-4, N-4, then T-4, expressing the thickness and hardness of the leather.

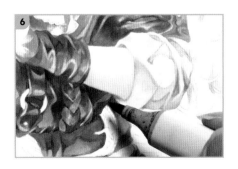

6 Add highlights by applying No. 0 to the lighter areas. Then, using BV23 and navy colored pencil, adjust the brightness of the leather as a whole.

TIP Subtle differences suggest depth

C, N, T and W Copic colors are all gray tones, but the base color is slightly different. Combining these colors adds depth to the look of leather.

HOW TO COLOR FRILLS

Example 1

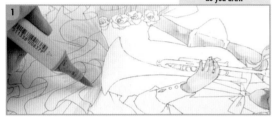

See the full illustration on page 52.

FLUFFY TUTU

A three-dimensional look and dynamic feel is important for a layered skirt such as this one. Add gradation and shadows to show the shape and movement of the tutu layers.

Colors used

- R0000
- R000
- R30
- R32
- R85

Create the tutu's arc as you draw

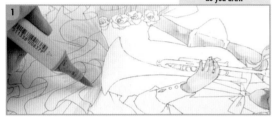

1

First, using R30, color one-third from the center of the tutu toward the outside. Keep the structure of each ruffle in mind as you make your brushstrokes, creating the arc of the tutu as you draw.

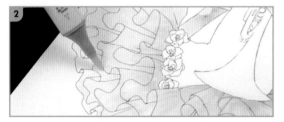

2

Continuing the arc in a similar way, blend the R30 with R000. Then color with R0000 last, in the lowest area.

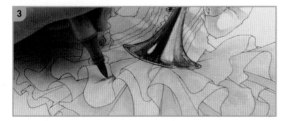

3

Add shadows to the ruffles with R32, with lines extending from the center of the tutu outward, and following their three-dimensional shapes.

TIP | **Apply gradation to each layer**

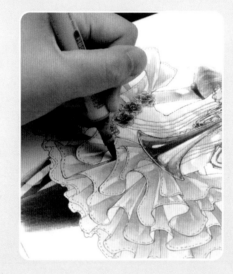

The changes on each layer are created with gradation applied from the inside out using R30 > R000 > R0000. The process of applying color is the same as shown in steps 1 and 2.

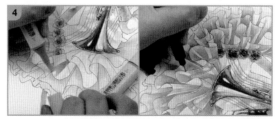

4

Use R30 and R000 to create gradation on the R32 from the previous step. Do this for each layer of the tutu. Then add stitch lines to give the layers more form and movement.

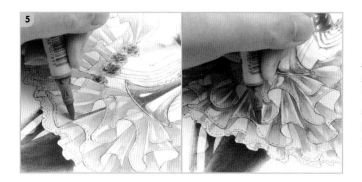

Add dark shadows with R85, and blend with R32, R30 and R000. After adding the entire shadow, add shadow to the individual ruffles using R85, R32 and R30 to finish.

SLEEVE DETAIL

Example 2

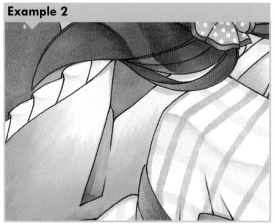

See the full illustration on page 88.

Leaving the edge of a frilly detail white when it has a base color will emphasize the shape of the detail and make it a more noticeable accent. Soften the edge if you want a softer impression.

Colors used

- [] Y00
- [] Y02
- [] Y08

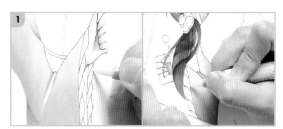

First, apply the base color Y00. Leave the edge white to make the shape of the frilly detail stand out.

After base Y00 is dry, add darker Y08 for the shadow of the frilly detail. Draw sharp lines to establish the edges. This becomes the guide for the next step.

Blend entire area for softness

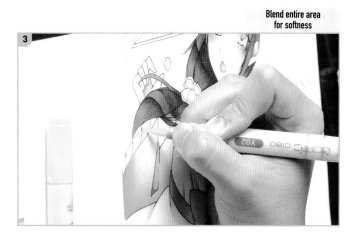

Layer Y02 on the area you drew with Y08 in the previous step, then blend the whole area for a softer look.

HOW TO COLOR TIGHTS

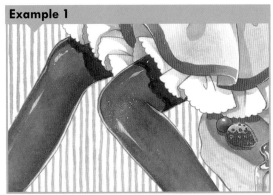

Example 1

See the full illustration on page 26.

BLACK TIGHTS

Black tights shouldn't look solidly dark. The color should vary where stretching occurs. The tights should look thinner where the legs are bent. Add skin tone to the area beforehand to set up a slightly transparent look.

Colors used

☐	YR00	■	E79
☐	E71		White
■	E74		

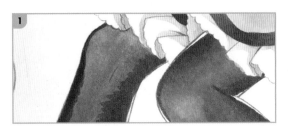

1

Apply the base color with E71 and the knees with YR00. Assuming the shins will be highlighted, add E79 to the back of the knees, brushing forward from the back.

2

Smooth texture

Blend the E79 from the previous step with E74 to make it smooth. Add highlights to the knee and shins using white for a glossy look.

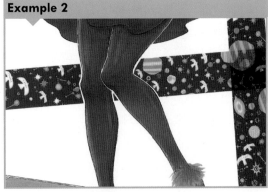

Example 2

See the full illustration on page 110.

COLORED TIGHTS

See-through areas on colored tights are created by layering color over the base color. Differentiating the colors of the tights creates a shiny look. Building layers of color creates areas of thickness and shadow.

Colors used

■	RV66
■	RV69
☐	R12

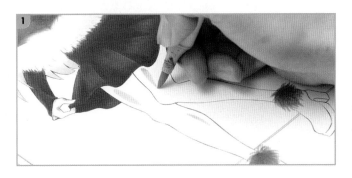

1

Use dark skin color R12 to indicate the hints of skin visible through the tights. Add them in the appropriate location, keeping the light source and leg shape in mind.

Layer RV66 on top as a base color for the tights. The same as with the previous demonstration, add color while keeping the light source and leg shape in mind.

TIP **Study structure to draw better**

When drawing an object, it is important to analyze and understand the structure and nature of the object in real life as you draw. Knowledge of the thickness of tights and how transparent they can look will help you create a more convincing illustration.

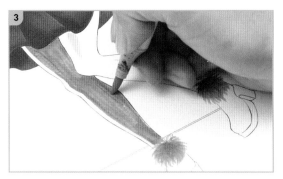

Layer R12, which was used for the skin color in step 1, on top of the base. Layer a few times to develop the tone, creating a see-through look.

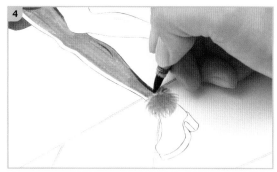

Add color with RV66, in a way that separates the R12 of the see-through areas, emphasizing the look of light hitting the legs.

Color for three-dimensional form

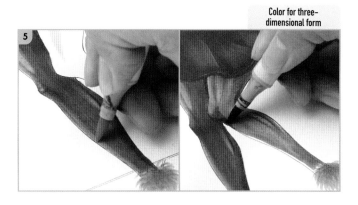

Color the darkest shadows with RV69. You don't need to color fully since this will be blended. Layer the base color RV66 to blend. Whenever you add color, keep a three-dimensional look and the direction of the feet in mind.

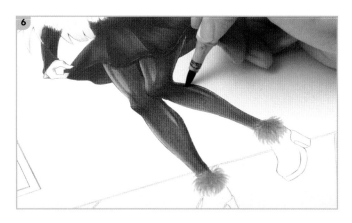

If the skin color R12 becomes overly noticeable, layer RV66 to adjust the transparency. Check the leg color for overall balance to finish.

YUE

About the Artist

Yue is a game illustrator who resides in Sappori. Find her on Instagram @y_u_e.

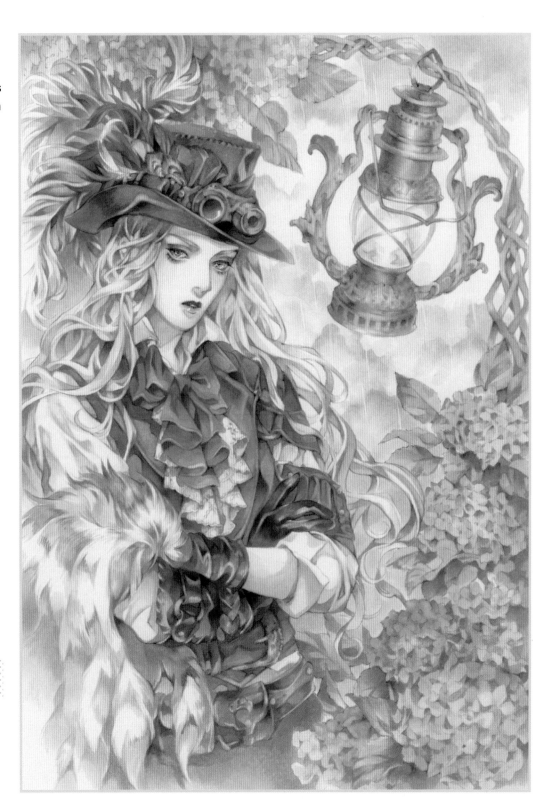

Materials

Copic markers, colored pencils (reddish brown, navy, black, purple), white pen, watercolor paper

Adding Colorful Tones to the Darkest Areas of Shadow

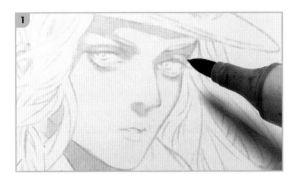

Color the entire skin with base color RV0000, and create general shadow with BV0000. Color the pupils clearly.

With BG0000, add blue tone to the areas where the shadows appear darkest, but avoid making them too heavy. Correct the face's contours with colored pencils.

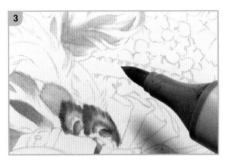

Color the hat's feathers with blue and purple base color (such as B60 and V01), applying strokes that follow the direction of the feathers.

Applying gray to the entire area will create a unified look, despite the variety of colors used.

TIP

After you finish coloring, add feather texture details with black colored pencil.

From Start to Finish

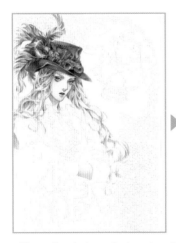 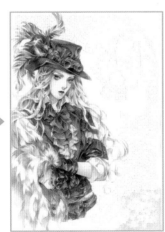 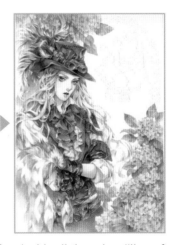

I like to begin by coloring the character first. I don't force myself to decide all the colors I'll use for every little detail before I start coloring. Instead, I choose a hair color that matches the skin and eyes, clothing colors that match the hair, and so on. I also like to incorporate colored pencil into my work—I just make sure to be careful as Copic markers can smear the colored pencil.

ANALOG > DIGITAL

Create Digital Color Samples

Using Copic markers to color your original line drawings will create a beautiful finish. The down side to coloring by hand is that you only have one chance to select your colors. But by using the computer to create a digital color sample, you can audition different color schemes before you commit!

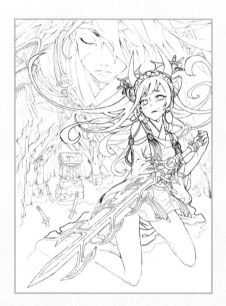

Add Color Digitally

Scan your original line drawing into the computer following the process on page 28 or take a photo using your phone. Use photo editing software to roughly block in color. Don't worry about staying in the lines—this is more of a quick sketch to experiment with color combinations and placement.

 TIP

Keep color balance in mind

This technique is especially useful for testing out the overall color balance of an illustration.

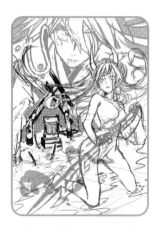

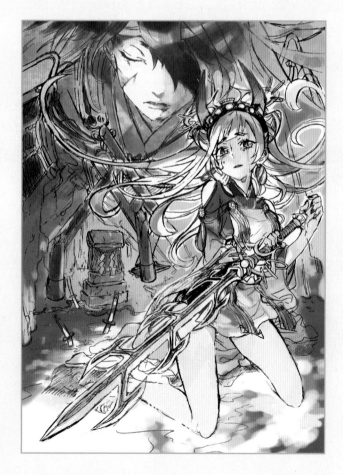

Paper vs. Computer Screen

Did you know that the color of Copic marker ink will change slightly when digitized? The following guide shows the difference in appearance between Copic marker ink on paper and on the computer screen. Keep this variation in mind when digitizing your artwork.

Copic Marker Color

Scanned Color

COLORING ACCESSORIES

Small items can reveal a lot about a character's world. They can also be symbolic, representing something that tells us more about the character.

HOW TO COLOR A LANTERN

See the full illustration on page 70.

BALANCING WARM AND COOL COLORS

The metal and glass of the lantern require cool colors. The lantern's light introduces warmth. Finish the details very carefully to make it look realistic.

Colors used

V000	E00	W-0
YR0000	E41	W-1
YR000	E42	No. 0
Y0000	C-2	
Y000	T-1	

1 Color the metal with Y0000, and layer Y000 to strengthen the tone. Blend down the center with E00 to express the reflection of light.

2 Add decorative detail with E41, W-0 and W-1. Draw with a light touch, and blend with No. 0 if it becomes excessive.

Add red for warmth

3 Add dark shadow using T-1 and C-2, envisioning the light from the lantern flame. Add red with V000 for warmth.

TIP **Make time for details**

Draw the wire crossed on the glass surface using W-1 at the far end of the light source to give depth to the lantern. Precision in these small details will add to the quality of your illustrations.

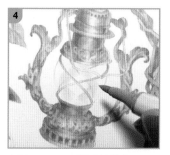

4 Add orange with YR000 on the area near the light source, and blend it into the surroundings using Y000 and YR0000.

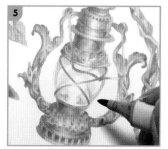

5 The dull color of the glass is created by adding W-0. Add the reflection of the light to the glass or the shadow of the wire using E41, E42 and T-1 to complete the lantern.

HOW TO COLOR A CANDLE

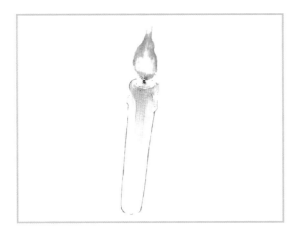

DRAWING FLAMES

The color of the flame varies quite a bit depending on the area. Detailed gradation and blending creates a flame with variety and movement that mimics real life.

Colors used

☐ Y000	▨ B23	
▨ R02	White gel pen	
☐ B000	Oil-based colored pencil: Red	

Blue is hottest

1 Using red colored pencil, draw the outline of the flame. The flame is hottest at its base, so the color is bluish there. Use B23 and B000 to create a small gradation.

2 The flame color is a gradation from blue to red. The middle color is yellow. Using Y000, blend the edge of the blue gradation made in the previous step.

3 Color with R02 along the outline of the colored pencil. Apply R02 one-third down from the top of the flame and add a touch in the center.

4 Blend the R02 inside of the flame using Y000. Use a lot of ink, as if the color were melting from the inside. Repeat the process of R02 to Y000.

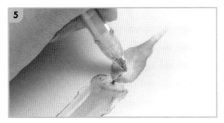

5 Place white at the center of the flame, drawing a circle using white pen, and blend with your finger. When you color the candle, leave areas white near the base and between shadows, to create a melted look.

TIP

Work with very wet ink

Push Y000 into R02 enough to saturate the area for easy mixing. Fade the tip of the flame from the bottom toward the top.

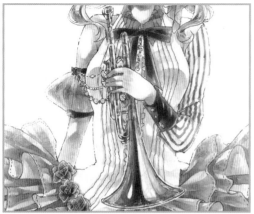

See the full illustration on page 52.

LAYERING THICKNESS AND ADDING SHINE FOR METAL

To create the thickness of the brass, the colors are built up with layering. Reflected light is expressed using gray or white. The trumpet is a focal point, so finish it carefully.

Colors used

YR23	W-5
Y000	White gel pen
Y23	

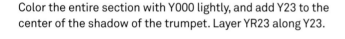

Color the entire section with Y000 lightly, and add Y23 to the center of the shadow of the trumpet. Layer YR23 along Y23.

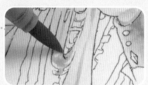

TIP **Start over to fix**

If you make mistakes when coloring with Y23, blend away the color with Y000, then add Y23 again after it dries.

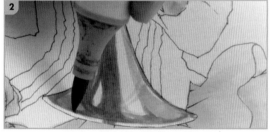

It is hard to correct the edge of the trumpet, so add YR23 very carefully. Layer YR23 further to add thickness.

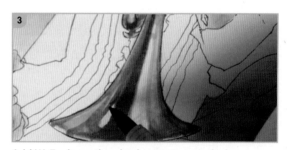

Add W-5 where the shadow gets very dark.

Sharp-point pen can be used for details

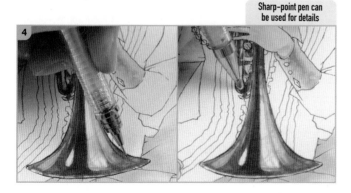

Add shadow along the edge using a sharp-point pen to create a worn look. Add highlights with white pen, strengthening the shine.

HOW TO COLOR A DAGGER

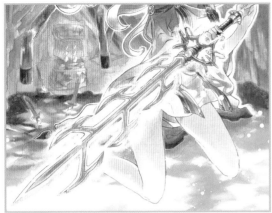

See the full illustration on page 126.

MAKING IT GLOW

Color the body of the dagger using light color in general. Layer dark color in the center to make the dagger look like it's glowing. Make sure the handle and decorative details are unified with the dagger body.

Colors used

YR24	B000	B37
YR31	B14	C-3
Y02	B21	C-5
YG11	B23	

Color over the edge for glow

1. Fill the groove of the center section with B21. Other colors are added later, so a general color is fine for now.

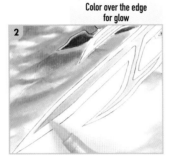

2. Add Y02 to extend over the edges, and layer YG11. The color Y02 starts to shine.

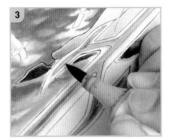

3. Layer B23 on the center of the dagger, to look like the color is overflowing from the groove.

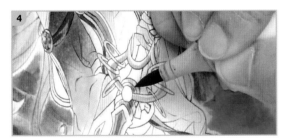

4. Color the metal decorative detail with base color YR31. Place B000 near the light source and add shadow with YR24 to develop the metal texture.

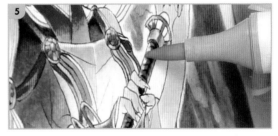

5. Color the handle with base color B14, the reflection with B000, the lighter section with B21, and the shadow and grooves with B37.

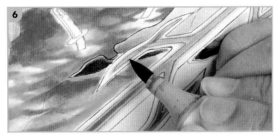

6. Color the base of the dagger with C-3. Layer C-5 where the metal bends to create thickness.

TIP Add glow to the metal

Where the metal doesn't bend as sharply, color with Y02 and YG11 to emphasize the light reflecting off it.

HOW TO COLOR A POUCH

USING SPOTTED GRADATION FOR LEATHER

Spotted gradation creates the look of soft leather. Use plenty of ink when blending to keep the color moist while you fine-tune the texture.

Color used

☐ N-2	White gel pen
☐ N-4	Oil-based colored pencil: Black
☐ N-6	
☐ T-4	

Spotted gradation creates softness

1 Use N-4 and N-2 as the base colors. Spotted gradation is more random than linear. Keep the look of soft leather in mind as you color.

2 After you finish coloring the base, color in spots in the same way as the previous step, using N-6 and T-4. Then blend the entire section using N-4 and N-2.

3 After the entire section dries, add shading using T-4. Create dimension by adding a thick edge.

4 Draw the pocket using black colored pencil, making a distinct line.

TIP Make it moist

Using a lot of ink, blend the dark color and the light color before they dry, to create the soft leather look.

5 Go over the entire section with the black pencil. Lay the pencil flat and don't sharpen the tip before starting. Color the shadow of the pocket.

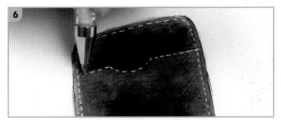

6 Use white pen to draw the stitching. Make the width of the stitches consistent. Touch up any bleeding edges on the pouch with white to finish.

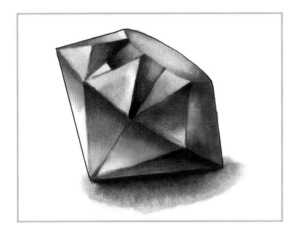

BUILDING TRANSPARENCY

Since actual diamonds are colorless and transparent, first color the entire area with gray, then create texture with shading. Add a bit of blue to the lightest areas to make the diamond look more transparent.

Colors used

- ☐ B000
- ■ B39
- ☐ C-0
- ☐ C-1
- ☐ C-2
- ☐ C-3
- ☐ C-5

Draw the overall shape in pencil, then outline the facets on the flip side of the paper. Color the base with C-0 (the facet lines remain visible).

On the top, create the gradation that becomes lighter toward the center, in the order C-3 > C-2 > C-1.

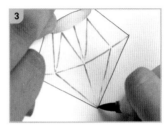

Trace the facet lines seen through the paper with C-5.

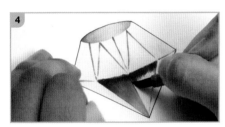

Color the individual facets of the diamond using gradation. Color the dark facets in the order B39 > C-5 and the lighter ones in the order C-3 > C-1.

TIP Enhance contrast with shading

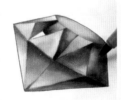

Contrast of light and dark facets defines the diamond. That contrast is developed further by the differences in the shading within each facet.

Blue adds transparency

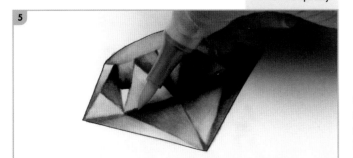

After coloring the entire surface of the diamond, add touches of B000 to the lightest areas, to create a more transparent look.

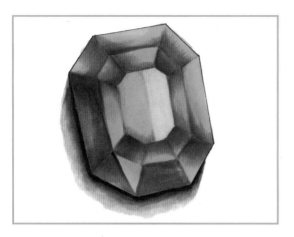

BUILDING SIMILAR TONES WITH CONTRAST

A colored gemstone is defined by planes, areas and edges of transparency and shadow, using variations of similar color. Contrasting edges are very important. The stone should be lighter where light passes through.

Colors used

YG06		G17
YG41		C-0
G05		
G07		

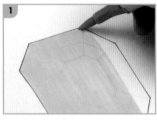 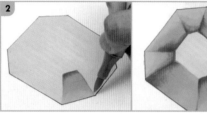

Draw the main emerald shape in pencil on the paper's surface, then outline the inner shapes on the wrong side of the paper. Apply YG41 as the stone's base color.

Color each facet from the innermost edge toward the outer edge in G17 > G05 > YG06 order along the pencil lines. Then, layer with YG41 from the outside in to soften the transition.

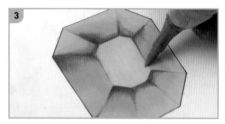

Layer C-0 over the center. By adding C-0, the shine on the emerald's surface is adjusted.

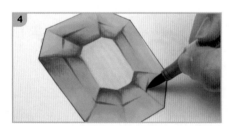 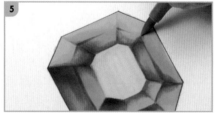

With G07, trace the inner line that breaks up each facet. Make sure the gradation applied in step 2 is dry, or these lines may bleed.

Add gradation with G17 > G05 for a darker surface, and G05 > YG06 for a brighter surface. The stone's texture is created by adding these contrasts of light and dark.

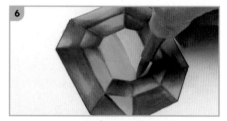

Color half of the brightest surface (the stone's center) with YG06 to complete the emerald. Add a little shadow to that half for contrast.

HOW TO COLOR A SAPPHIRE

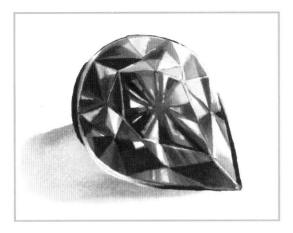

CONVEYING COMPLEXITY

Depending on the cut of the gemstone, additional planes of light and shadow can be created. The light passing through the sapphire also helps to define it and can influence the colors in an effect based on a real phenomenon.

Colors used

☐ BV20	☐ B000	▨ B23
☐ V000	☐ B01	■ B79
☐ V01	☐ B14	☐ No. 0
☐ V04	☐ B16	White gel pen

1

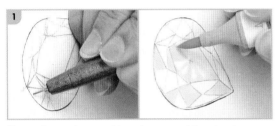

Draw the main sapphire shape and facet edges with warm gray Copic Multiliner. Color some facets with light B000, and the center in a pattern, keeping the cut in mind.

2

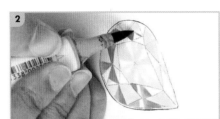

Add B01 and B14 on the other facets, in triangular or diamond shapes as done in the previous step, to begin defining the cut details of the sapphire.

3

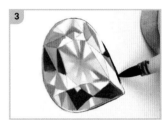

Draw deep shadows with B79, and adjust the shade with B23. Color part of it with gradation, for variety.

4

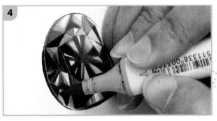

Apply V04 and V01 with No. 0, for an accent color that describes the light going through the sapphire.

TIP How to add an accent

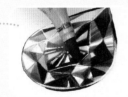

Consider the colors of the illustration when choosing an accent color. For this sapphire, the accent color provides gradation between the white area and the darker B79 shadow.

5

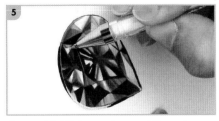

Create highlights using a white gel pen, adding light lines or irregular triangle shapes within the sapphire's facets.

6

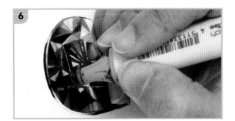

Add B79 and V01 along the white. Pure white is also nice, but adding color makes for a smoother look.

7

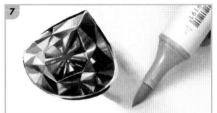

Apply B000 for the cast shadow. Add V000 also, for a prismatic effect.

CREATING ROUNDNESS

Pearls are white in real life but require additional colors to read as pearls in illustrations. Using contrasting colors like pink and blue creates transparency that cannot be made with white alone. The pearl's shine is conveyed with carefully placed highlights.

Color used

V000	No. 0
BG000	Opaque white
W-0	

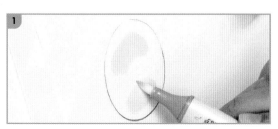

1

In order to blend the color added later, first color the area where the light hits strongest using No. 0. The light source is in front of the pearl, coming from above.

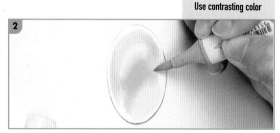

Use contrasting color

2

Place blue tone BG000 in the center, and add base color V000 on the sides and top. Leave the edge of the pearl white to communicate the pearl's natural color.

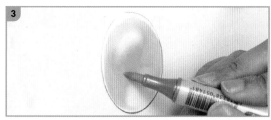

3

Add the shadow on the bottom half of the pearl with W-0, building the roundness and depth of the pearl.

4

The part of the pearl that is closest to the light source is brightly lit, with almost no color. To express that, use No. 0 on the top of the pearl, removing excess color.

Don't forget the cast shadow

5

Add highlights with opaque white to create the shine on the pearl. Ground the pearl by adding the shadow it casts on the surface where it sits. Use two colors for a cleaner finish.

TIP — Scrape off excessive highlights

If you add too much highlight, scrape some off with a razor blade after the opaque white is completely dry, and adjust the shape.

HOW TO COLOR AN APPLE

See the full illustration on page 26.

DEVELOPING WITH MULTIPLE COLORS

This apple is red, but using only red to color it won't look natural or interesting. Instead, try using two tones of red, plus a few cooler tones to express a ripened look.

Colors used

R05	Y32	E09
R08	Y38	E18
R30	YG11	E33
Y02	E08	White gel pen

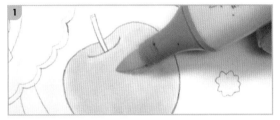

1 Color the entire area with base color R30. Then color the bottom of the apple with YG11, sweeping the brush upward from the bottom. Apply Y02 for the highlight area.

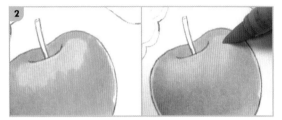

2 Leaving the sections of YG11 and Y02 colored in step 1, color the rest of the apple with Y38. Then, using Y32, blend Y38 with the base color (R30).

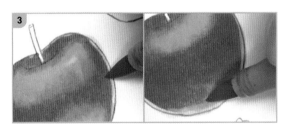

3 Add R05, except for the bottom of the apple and the highlight, and blend with Y38. Layer with R08 and blend with R05.

TIP Add bluish red for ripeness

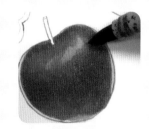

For the reds of the apple, use not only warm R tones but also a few cool E tones, which express the ripeness of the apple.

Brushmarks create skin texture

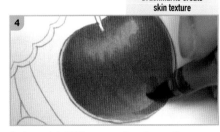

4 Color with E08, sweeping from the center toward the top and the bottom. Let your brushstrokes create the texture of the apple's skin. Build color with E09 and blend with E08 and R08.

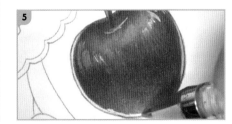

5 Add blue tone at the bottom with YG11. Color the stem section with E33 and E18. Add the white highlights last, and blend with your fingers to complete.

HOW TO COLOR GRAPES

See the full illustration on page 26.

SHADING FOR PROPER SHAPE

The placement of shading and highlights is what makes these grapes appear round and realistic. The coloring method is the same for both bunches.

Colors used

Blue grapes:	Purple grapes:
BV00	V01
BV17	V06
BV29	V09
Opaque white	Opaque white

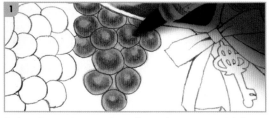

1 Color the entire section of purple grapes with base color V01. Draw the circular shadow with V06, leaving the center highlight and outer edge light, and blend with V01.

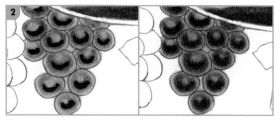

2 Apply dark V09 below each center highlight, and blend with V06. Use V01 in addition to blend the entire area.

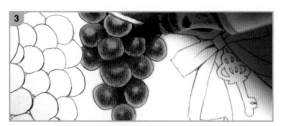

3 Color the dark areas between the grapes with V09. Add the shadow with layers in mind, creating a three-dimensional look. Then use V06 to blend with the surroundings.

Finger-blend for matte highlights

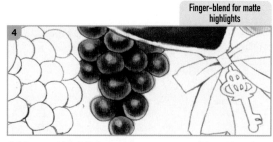

4 Add round highlights using opaque white. Blend each highlight with your finger to create a matte look.

TIP **Repeat the process in different colors**

 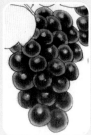

Change the look by changing colors. The coloring process remains the same. For blue grapes, use BV17 and BV29 along with base color BV00.

See the full illustration on page 26.

MAKING MANY TEXTURES IN THE SAME TONE

Different types of texture such as gelatin, fruit and sauce are unified when they are the same color. Use various methods of coloring and adding shadow to differentiate them.

Colors used

R02	R35	E71
R05	R37	No. 0
R08	R39	White
R22	R59	
R27	E40	

Use No. 0 to create cream

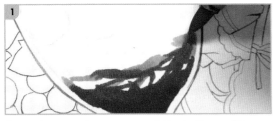

Draw the strawberry sauce at the bottom of the glass. Color R37 as the base and layer R08, pulling your brushstrokes to the sides. Blend as you brush on R22.

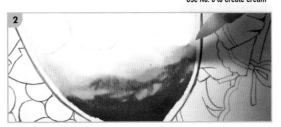

Spread the R22 from the previous step with No. 0 to convey the mixture of strawberry sauce and the whipped cream layered above it.

The outer edge and core of the sliced strawberries is a gradation of R27 > R22 > R02 from the outside in. The presence of the glass is created by blurring with No. 0.

Color the base of the gelatin layer with R02, maintaining the line drawing. Begin coloring the gelatin cubes with R05.

Color the rest of the cubes with R35, then darken the shadowed sides with R37. Add R05 overall to adjust the tone.

Fill in the space between the cubes with R59 and blend lightly using R37 and R39. Color the surface of the cubes with R37, then lift the color with No. 0 to complete their three-dimensional look.

With E40, add shadows on the whipped cream under the gelatin, between the strawberries and up the sides of the glass. Add darker shadow with E71 and blend with E40 to finish.

See the full illustration on page 26.

FINE-TUNING REALISTIC DETAILS

Small details, such as the bubbles and the sear marks from baking, create the realistic texture of sponge cake.

Colors used

- R05
- R08
- R22
- R27
- YR30
- Y32
- YG25
- G94
- E09
- E23
- E40
- Opaque white
- White acrylic paint

Reference photo

1

Color the sponge area with YR30. Layer twice or three times to build the color. Refer to a real cake for the tone (see photo at right).

2

The bottom and side of the sponge have sear marks; add them with E23. After coloring these lines, blend them into the sponge a bit with Y32.

3

Shadow gives dimension to white icing

Use the brush tip of Y32 to draw sponge bubbles. Then draw the shadow of the white icing with E40.

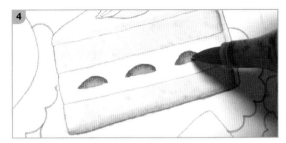

Draw the round edge of the strawberries with R27. Then add gradation in the order R22 > R05 toward the straight end to finish.

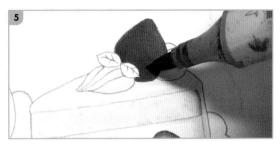

Color the base of the strawberry on the cake with R08. Keep the shadow in mind and add gradation with E09. Express the rough texture of the berry as you color.

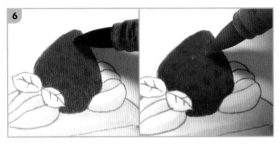

Color the seed dimples with E09 and layer R08 to blend lightly. Then, use the brush tip of Y32 to lift the darker color for the seeds.

TIP **Add shine with white**

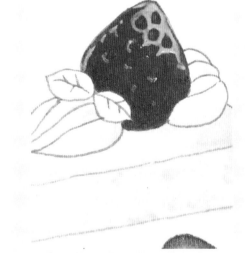

Add opaque white on the strawberry where the light hits it. Spread it around the seed dimples, and also add a few small highlights on the dimples that barely catch the light.

Color the base of the mint leaves with YG25 and draw the veins with G94. Then blend the entire section using G94 and YG25.

Lightly stamp powdered sugar detail

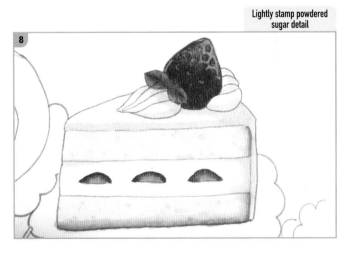

Pick up a small amount of acrylic white paint on a sponge or makeup sponge and stamp lightly on the strawberry and the mint leaves. This creates the texture of powdered sugar.

SHIN

About the Artist

SHIN developed an interest in art while attending college. SHIN is from Shizuoka, Japan.

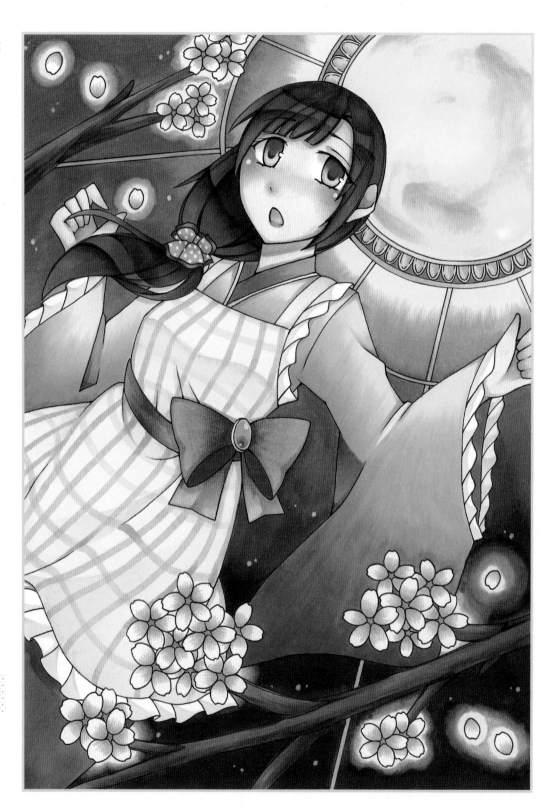

Materials

Copic markers, Copic Multiliner pen (black), white gel pen, Kent paper

Giving the Hair Some Life with a Halo Effect

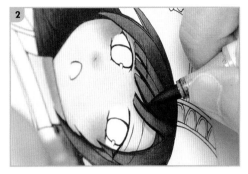

Color the hair using gradation from E29 to E37, then E35, taking the light intensity into consideration.

After completing the overall coloring, start coloring E29 along the line drawing to enhance the hair line.

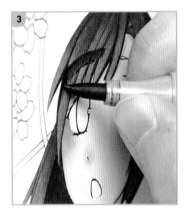

Finally, add a halo effect to the hair. This is commonly done using white and No. 0; however, in this illustration, the area surrounding where the light appears is darkened, emphasizing the lighter area.

This time, E29 is used as the darkest color, with gradation from E37 to E35.

From Start to Finish

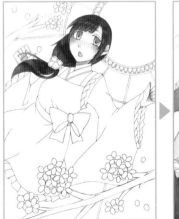

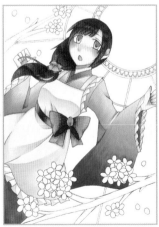

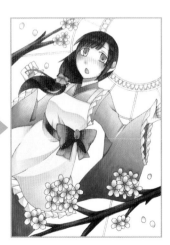

I like coloring skin and hair, so I always start with one of these two elements. Next, I tackled the clothes and background. I tend to move around when coloring, changing the area where I work if I'm waiting for ink to dry in a certain spot or if I get tired of working on a complex area and need a break.

ANALOG > DIGITAL

Layering Color: Part One

When you create an image digitally using a program such as Adobe Photoshop, you can layer color to create a blended effect using the Multiply Blend Mode. This same result can also be achieved when coloring by hand using Copic markers.

On the Computer

When you draw digitally, you can use various effects to create layered color. If you draw each part of the image separately, you can then combine them and apply Multiply Blend Mode to create a single image where the color is layered naturally. This effect is especially visible when layering a transparent and a solid object, as shown in the example below.

Multiply Blend Mode in Adobe Photoshop

Position the two images on separate layers. At this point, only the top image will be displayed.

Right click on the top layer in the Layer Panel, then select Blending Options. A Layer Style window will pop up. Select Multiply from the Blend Mode drop down menu.

In the finished example, the layers have been combined without ruining the color.

With Copic Markers

Because Copic markers are fast-drying, you can create mixed colors by layering to replicate the same multiplied effect as on the computer. Let's use the same example of the glass of liquid. The liquid is transparent, so start out by coloring the straw first. Let the ink dry, then color the liquid on top to achieve the transparent effect.

TIP

Layer the colors to create the transparent liquid

When layering colors, make sure to wait until the first color dries. You don't want to blend the colors but instead, create a multiplied effect.

TIP Creating a multiplied effect with Copic markers

It's helpful to know which colors can be layered to create this effect. The following guide shows the results of layering different colors.

Green + Blue
This example features two cool tones. The green straw becomes darker when layered with blue, but does not change hue.

Red + Green
In this example, the red straw becomes dull when layered with green.

COLORING NATURE

Incorporating elements of nature in your illustrations can describe the setting and appeal to the senses. Observing flowers, grass and wood in real life will help you draw them more realistically.

HOW TO COLOR CHERRY BLOSSOMS

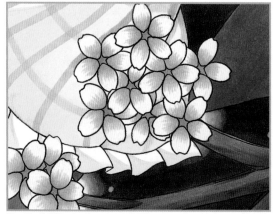

See the full illustration on page 88.

COLORING WHITE PETALS

Adding light color to white flower petals will make them appear more transparent and give them some texture. Leaving them completely white would make the petals look too flat.

Colors used

☐	V01	☐	R32
☐	RV000	☐	Y08
☐	R20	☐	Y17

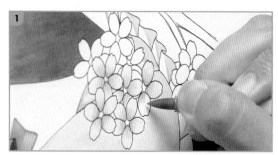

Color the petals using R20, starting darker near the flower centers and getting lighter as you move outward, as real petals look. Keep the color light overall.

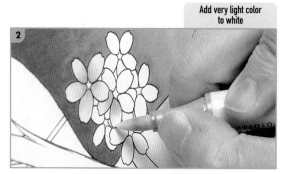

Add very light color to white

After coloring with R20, layer RV000 on top as you create gradation.

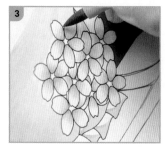

Draw the faint lines of the petals with V01. Brush from the inside out, making crisp, thin lines.

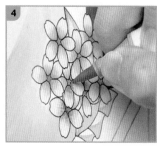

Color the flower centers with R32 and add stamen to the petals with Y17.

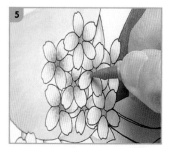

Blend Y17 from the previous step with Y08. Adding yellow makes the blossoms look more realistic.

HOW TO COLOR ROSES

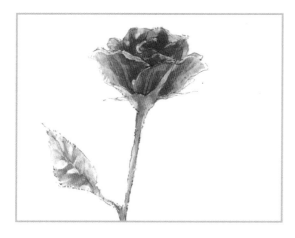

ADDING MULTI-TONAL SHADOWS

To create a three-dimensional look for layered petals like the ones found on roses, build the shadows with multiple tones of color. Use Copic Multiliner to create a nice accent for the thorns of the rose.

Colors used

R000	G20
R02	G21
R14	G94
R46	White gel pen
YG03	Copic Multiliner: Wine

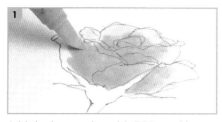

1 Add the base color with R02, working from the bottom of the flower up. Add R000 next to create gradation.

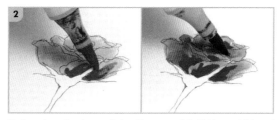

2 Color the shadow of the flower with R14, and blend with R02 to adjust. Using the area colored with R14 as a guide, add dark shadow to the bottom area with R46.

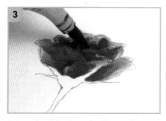

3 Blend with R14 before the R46 dries up. After it dries, define the shadow more clearly with R46.

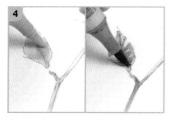

4 Color the greenery using YG03 and G20. Then detail the veins of the leaves and the stems with G94, and blend with G21.

TIP · Blend with white pen

Draw the thorns with Wine Copic Multiliner. The color stands out, so blend it a bit with white gel pen.

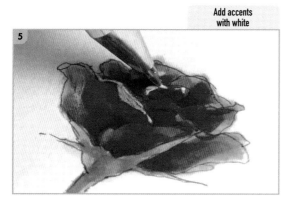

Add accents with white

5 Add white using white pen on the edges of the petals. Use your finger to adjust the tone.

See the full illustration on page 70.

KEEPING COLORS BRIGHT

Create different tones among the bunches for vivid color. Be careful not to add too much shadow or layer too many colors, as that may dull the brightness of the blooms.

Colors used

BV20	YG11	C-2
V000	YG91	N-2
V01	G40	T-0
R00	BG10	T-1
YR0000	B41	W-1
YR000	B60	W-2
Y0000	E40	Colored pencil:
Y000	E41	Navy
Y23	C-1	

Add shadow overall with B60. Layer YR0000 on some bunches to dull the color a bit. Layer V000 and T-0, and color between the hydrangea petals with BV20.

Color the blue-green bunch with BG10 and G40, and the purple bunch with V01 and V000. Emphasize the overall shadow with W-1, T-1 and N-2, to adjust the shape.

Develop the bunches with subtle tones. Color the general shape of the shadow with B60, then color overall with YR000 and E41. Draw irregular round shapes with B60, T-0 and Y0000 to create more petals.

Don't combine too many colors

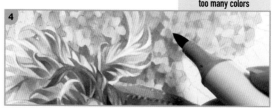

Add red with R00 and V000, and blue with B41. Be careful not to add too many colors, or the hydrangeas will look chaotic. Then, add dark shadow with C-2 and N-2.

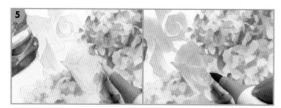

Color the ends of the leaves with YR000, and from the center to the end with Y000 for a gradation of beige and yellow. Add veins with YG11 and E40 to clarify the leaf shapes.

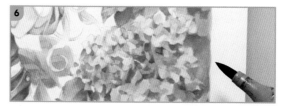

Add brightness with Y23, and blend overall with YG91 and E41. Emphasize the darker area of the shadow with W-1, W-2, C-1, C-2 and navy colored pencil to complete the hydrangeas.

HOW TO COLOR PANSIES

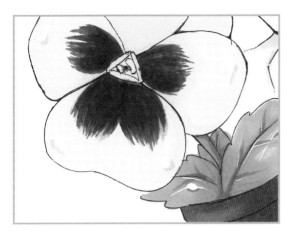

LAYERING COLOR

Keeping the thinness of the petals in mind, a three-dimensional look is created by darkening areas of the petals in layers. The thickness of the leaves balances out the overall illustration.

Colors used

☐ Y11	▣ E47
☐ G02	Opaque white
▨ G07	

Be aware of the thin petals

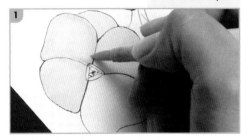

Apply Y11 as the base color. The petals are thin, so at this stage, apply just enough color to cover.

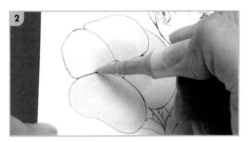

Layer Y11 on the center to darken the color. Imagine the shadow created by the layered petals.

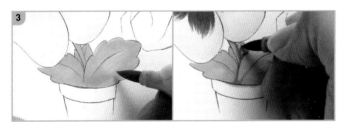

Use G02 for the base color of the greenery. Then add darker G07, keeping the direction of the leaf veins and the petal shadows in mind.

TIP **Contrast thick and thin**

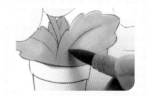

Adding darker green to the leaves creates thickness that contrasts with the thinner flower petals.

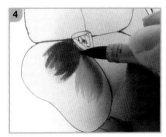

Use E47 for the darker color of the petals. Create a three-dimensional look with your shading.

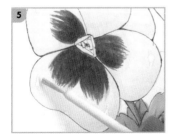

Apply the water drops with opaque white. Keep the highest areas of the petals in mind as you add them.

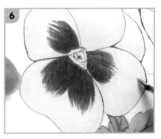

With diluted white on the tip of a pen, draw subtle marks indicating water flowing down the petals.

See the full illustration on page 70.

DEVELOPING COMPLEX SHADING

Drawing wood involves being especially attentive to where the light hits it, as you distinguish the light and dark tones. Adding blue at the end can give depth to the color.

Colors used

- BV20
- Y0000
- B60
- E41
- E42
- W-1
- W-2

1 Add base color E41 to the entire area. This tree is tangled in a complicated way, so imagine the light source and envision where the shadows or highlights will be.

Create hardness with contrast

2 Add yellow with Y0000 and darken the shadows of the tree with W-1 and W-2. Imagine the hardness of the rough tree to create the difference in contrast.

3 To express the depth of the tangled tree, layer E41 and E42. Don't overdo the details or you might erase the effect of the depth.

TIP Walk away then re-evaluate

If you layer on too much color, your illustration may become messy, or look flat even though you meant to add dimension. Take a break, then return and recheck the balance with fresh eyes.

4 Add blue tone on the simply colored sections for additional depth, using B60 and BV20. This blue tone goes well with the Y0000 added in step 2.

HOW TO COLOR GRASS

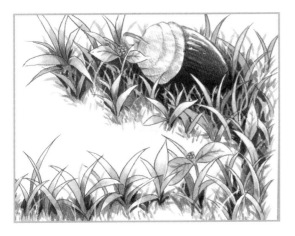

VARYING HEIGHT AND COLOR

Draw different heights of grass to create overall depth. Use lighter color toward the top of the blades and darker color lower to create a natural, three-dimensional look.

Colors used

YG11	G99
YG25	No. 0
G24	Opaque white
G94	Copic Multiliner: Olive

Brush in the direction of growth

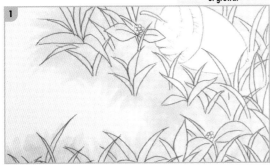

Make a line drawing with olive Copic Multiliner. Then add YG11 for the base color, brushing in the direction of finely growing grass.

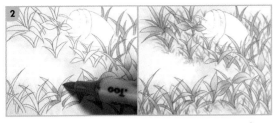

Leave the tips of the grass and color the rest of it with YG25. Then color the tips with YG11. Draw short grass with YG25 and G24, moving your brush tip from the bottom up to look like it grows from the ground.

Using G99, fill in the gaps between the short grass drawn in the previous step. Blend G99 with G94 and draw shorter grass.

Remove color from the tips of the long grass using No. 0, to create the impression of shine. Adjust the shading in sections of the grass to create the proper depth. Add highlights with opaque white and make veins on the leaves to finish.

COLORING BACKGROUNDS

The background can often become the "second clothes" for your character, describing the setting or situation as well as expressing the mood or emotion of a scene.

HOW TO COLOR A CLOUDY SKY

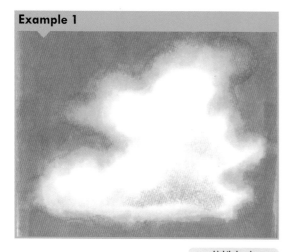

Example 1

FLUFFY CLOUDS

Color the sky with bright, solid color for a crisp look, but soften the edges of the clouds for realism. Don't forget to add the shadow, giving your clouds dimension and texture. Use the photo on the next page for reference, or step outside and look up at the sky.

Colors used
- BV20
- B00
- B04
- No. 0

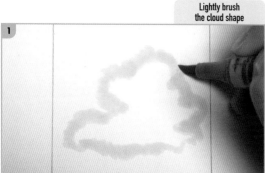

1
Lightly brush the cloud shape

Using B00, draw the outline of the clouds. Lightly brush instead of drawing hard lines.

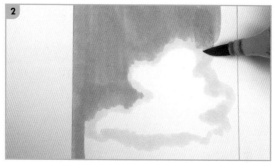

2

Using B04, apply solid, flat color for the blue sky. This time, leave some of the outline of the B00 from the previous step. We'll blend this later to create texture.

TIP — Try an airbrush tool

The Copic Airbrush System is a device that lets you snap a Copic marker into place to convert it for applying color the way an airbrush does. This will give you even coverage and allow you to try different effects. The system works with Sketch and Classic Copic markers but not Ciao.

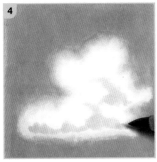

3

After coloring the flat sky, blend the cloud outline drawn with B00 and the edge of B04 using B00. Then blend the entire cloud area using No. 0.

TIP Blur the edge as you draw

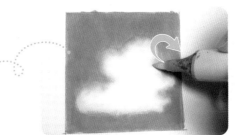

To soften the edges of the clouds, move the brush tip of No. 0 in a circle over the area. This blurred edge keeps the clouds from appearing flat.

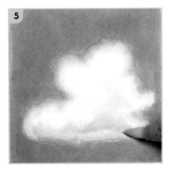

4

Add shadow on the bottom right with BV20. Keep the direction of the sun in mind, and think about the shape and height of the shadow.

5

Soften the BV20 shadow with No. 0 and create depth with shading. Then blend the entire shadow with No. 0.

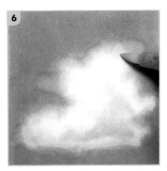

6

After the shadow is blended, remove color from the inside of the cloud with No. 0. Adjust the overall tone to finish.

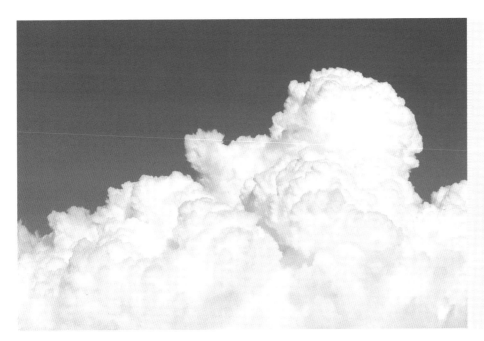

USE REFERENCES TO REAL LIFE

If you cannot imagine the three-dimensional look of clouds, go outside and look up at the sky or use this reference image.

Reference photo

Example 2

See the full illustration on page 110.

HAZY CLOUDS

Layer lighter blue evenly to create a clear blue sky, and make clouds that are more hazy and wispy by applying opaque white and then pressing into it with facial tissue. Make the outer edges more transparent and less defined.

Colors used

☐ B02
Opaque white

Work in light layers

1

Apply B02 from the top down and across your paper, making the color slightly lighter near the bottom.

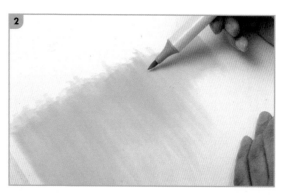

2

Apply multiple light layers of B02 to achieve a clear blue tone. Coloring a wider area can make it harder to apply color evenly, so add as many layers as needed.

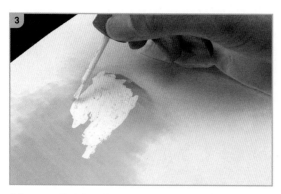

3

After you finish coloring the sky, make a cloud shape using opaque white. Just create the general shape at this stage; we'll fine-tune it later.

TIP Layering with one color

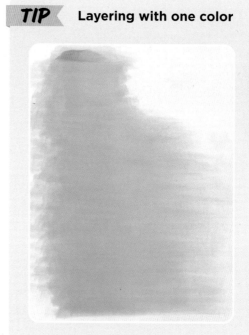

Layering the same light blue many times will create the look of a clear sky on a sunny day. Adding other colors will give your sky a different look.

USE REFERENCES TO REAL LIFE

Hazy clouds appear as if they have been created with a brush. Remember, it's important to think about capturing texture when coloring with Copic markers.

Reference photo

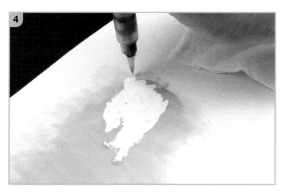

Drop water onto the white using a pen tip or another tool that allows you to drop a very small amount. Too much water will soil the paper.

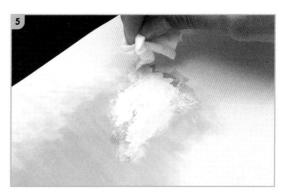

Press into the wet edges with facial tissue to develop the clouds, expressing their edges and texture.

Add diluted white to a round pen tip and draw faint beams of light using a ruler. As you draw, imagine the shape of light as it shines from the sun.

TIP **How to draw beams of light**

When you draw beams of light coming from the sun, vary the lengths of the lines to make it look natural. Changing the amount of lines or their thickness will express variations in brightness.

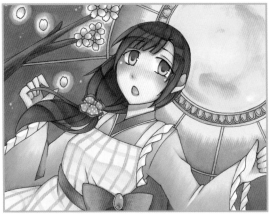

See the full illustration on page 88.

MOONLIGHT

A night sky isn't necessarily black. The color varies depending on the moonlight, starlight (see the reference photo) or light coming from other sources. To express bright moonlight on a clear night, use gradation that also surrounds the details.

Colors used

V01	V17	Y17
V09	Y00	YG00
V12	Y02	No. 0
V15	Y08	White gel pen

Color around the cherry blossom petals, in the order of V09 then V17, from the outside in, to create a gradation base.

Add color on the gradation made with V09 and V17 from the previous step. In the order of V15 > V12 > V01 > YG00, draw the moonglow surrounding the petals.

Color the remaining sky. Create gradation with light from the moon in mind. The color is in the order of V09 > V17 > V15 > V12 > V1 > YG00, with the same process that was used around the petals in the previous step.

> **TIP** Approach lighter color carefully
>
>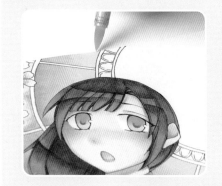
>
> For the night sky gradation, color carefully as the color gets lighter. Sloppy coloring can dirty the lighter color.

> **TIP** Switch up the stars
>
> The brightness and positions of the stars in starry skies can vary. You can even make constellations by drawing lines between stars. Draw known constellations or something original.

Draw stars using a white pen, making dots varying in size and opacity. The distance between the stars should vary as well.

USE REFERENCES TO REAL LIFE

A night sky is composed of various colors, not just black.

Reference photo

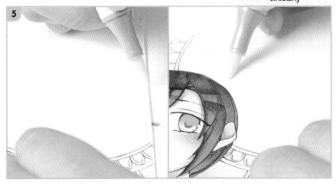

Color round shapes circularly

5

Color the moon with Y00 first, as a base. Color in a circle shape from the outside in to create even color.

6

After coloring the base, color a darker area on the moon with Y08. To express shades of the area, draw lighter dents using Y08.

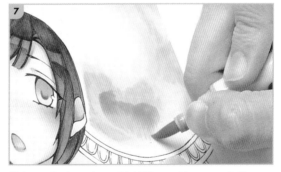

7

Color a dark crater with Y17, creating a realistic shape and texture by referring to a picture of the moon.

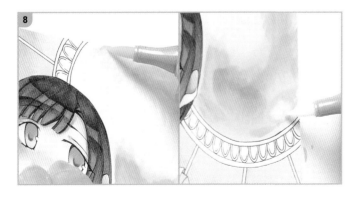

8

Blend the crater and dents with Y02, softening as you press the brush. Create areas of dim light with No. 0 to finish the moon's surface.

HOW TO COLOR RAIN

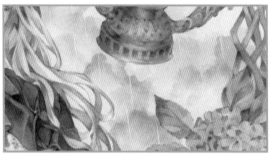

See the full illustration on page 70.

FALLING RAIN

Rain can be drawn in different ways, to express any mood you want. The method used here involves drawing it with line and emphasizing it with surrounding color.

Colors used

B60
White gel pen

1 Draw rain lines using white pen. Make them straight but vary their thickness and placement.

Darken around the white lines

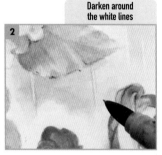

2 Layer B60 on both sides of the rain lines to emphasize them and create depth.

TIP **Blend to look natural**

When you draw rain lines, move the pen tip smoothly. Create natural-looking rain by blending the lines into the background a bit with your fingertip.

HOW TO COLOR THE OCEAN

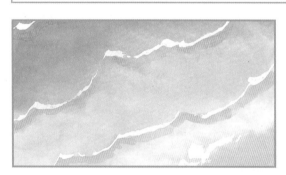

WAVES

Draw the water using gradation. Imagine the movement of waves to understand the balance between the shadow of the wave and the white where it breaks.

Colors used

BG000	E000	No. 0
B02	W-1	White

1 Apply E000 on the sand area. Then color the transparent sand area, where you can see the sand through the water, with BG000.

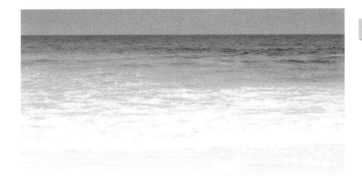

Reference photo

TIP **Decide the shoreline beforehand**

Before you start coloring the sand and water, decide where the sand area will meet the lightest part of the ocean, then add No. 0 there to soften it.

Add No. 0 on the border of the light area of the ocean with BG000 from the previous step and the darker area of the ocean. Color quickly before the BG000 dries, to blend it well.

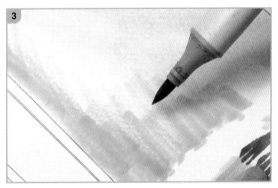

Color the darker area of the ocean with B02. Blur the border of the light area BG000 with No. 0 and make gradations.

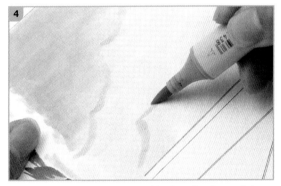

Add shadow with W-1, considering the flow of the wave. The wave is close to the sand, so draw soft shapes. Observing real waves will help you with this.

Go thick and thin for bubbles

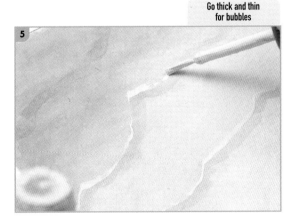

Add white on the W-1 shadows to create bubbles where the waves break. Draw thickly where the bubbles are grouped together and thinly where the bubbles are spread out.

HOW TO COLOR LAKE WATER

See the full illustration on page 126.

BE SURE TO MAKE WAVES

In drawing, darks help define the light, and water is no exception. The surface of moving water is wavy, so the shapes of the lights and darks should vary to show that movement.

Colors used

- ☐ Y000
- ☐ BG000
- ▨ BG07
- ▨ BG09
- ☐ BG23
- ▨ BG53
- ☐ B00
- ☐ B21
- ▨ B45
- ☐ No. 0
- Opaque white

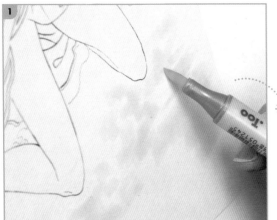

Apply the base color of the water using BG000. As you color, imagine the shapes the waves make on the surface of the water.

TIP **How to cover a large area**

A chisel tip will color a large area more quickly and evenly. For a wider range of tones, press the angled tip into the paper in areas where you want darker color.

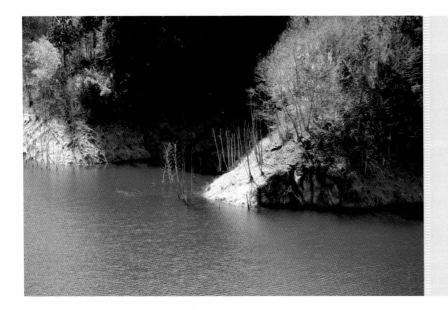

Reference photo

USE REFERENCES TO REAL LIFE

When drawing natural objects, look for a picture that is close to your image or take photos of objects for reference. Study the actual colors and movement the objects in real life to finish them more realistically.

Add darker color (BG07) to express the depth of the lake, using the previously applied BG000 as a guide. Leaving some triangular areas without color will help the water look wavy.

Add the glow using Y000 along the edges between the white and darker areas of color. The strength of the glow can be adjusted by the number of colors you add in the gradation between the lightest and darkest areas.

TIP

How to soften the glow

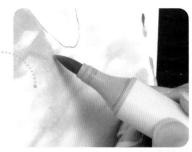

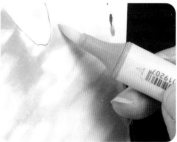

For areas where you want a softer glow, add more gradation steps between the highlight and the base color. In this scene, the light is coming from the lake bottom instead of the sky above, so the gradation is reversed.

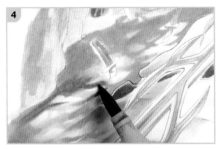

Describe the clothing that is underwater. To drop shadow on the water surface, the color gradation should get lighter as you go down, using B00 > B21 > B45, which is lighter than the B37 base color of the clothing.

Adjust the overall tone. For instance, to make the water surface behind the person darker, add BG09. Remove color with No. 0 if you add too much yellow.

Finish by adding a splash effect using opaque white. Use white also to adjust the tone of the remaining area.

ANALOG > DIGITAL

Layering Color: Part Two

When working in Adobe Photoshop, Screen Blend Mode can be used to add brightness to the illustration. This same effect can be replicated when coloring a hand drawn image using Copic markers.

On the Computer

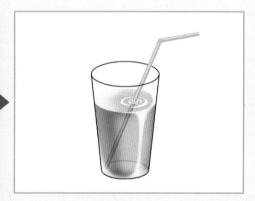

In contrast to using Multiply Blend Mode (refer to page 90), Screen Blend Mode involves layering colors to create white, increasing the brightness of an image. This technique is often used when adding highlights or when you'd like the bottom layer to come through as a background color.

Screen Blend Mode in Adobe Photoshop

Create separate layers for the main image and the highlight areas. Place the highlight layer on top of the main image layer.

Right click on the top layer in the Layer Panel, then select Blending Options. A Layer Style window will pop up. Select Screen from the Blend Mode drop down menu.

In the finished example, the black is not reflected and only the light is compounded. The brightness increases and the highlights shine naturally.

With Copic Markers

To create the same effect using Copic markers, add a screentone on top of your illustration. First, color your illustration using Copic markers. Next, apply a screentone sheet on top of your work. Finally, remove the backing from the screentone sheet. The dot pattern from the screentone sheet will have been transferred to your illustration. This technique is commonly used in manga.

TIP

There are various types of screentones available on the market. In addition to creating highlights, screentones can also be used to depict texture, background, and emotion.

The dots from the screentone create a highlight effect in comparison to the dark areas of the illustration.

TIP Creating a screen effect with Copic markers & screentone

Screentones work well when used in conjunction with Copic markers, as the markers create a nice smooth finish, making the application process easy.

Use a knife
Use a craft knife to lightly scratch the backing of the screentone to create special effects and patterns.

Layer screentone
Layer pieces of screentone to express depth—just be careful as layering can create a striped pattern in the areas of overlap.

JUNKO KITAMURA

About the Artist

Junko Kitamura prefers to draw on paper but has recently begun experimenting with digital illustrations created on her smartphone.

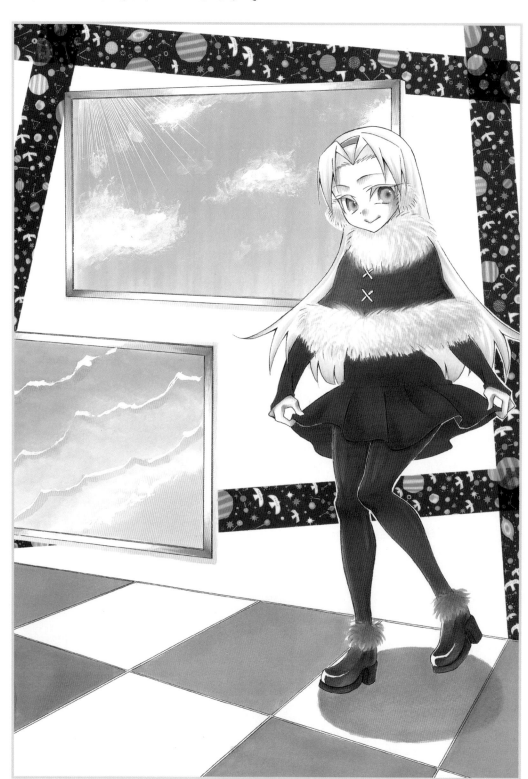

Materials

Copic markers, G-nib pen, round-tip pen, ink, ruler, cutters, tone knife, opaque white, patterned tape, drawing paper

Replacing to Fix

The original sky made in this illustration was unsatisfying, but rather than trying to make adjustments, sometimes it's easier to start from scratch. A new sky was drawn separately and added in place of the original one.

Before

After

Make a new sky separately, on photocopier paper. Since this will be pasted over the original sky, you don't need to make distinct edges, but draw it a little larger than the original.

TIP Try out a tracing table

A tracing table is a tool that allows a light from below to shine through the paper placed on it. This makes tracing an illustration very easy, along with checking the position and size of the replacement and adjusting as necessary.

A cutter and ruler are used for cutting straight lines. Curves are cut with a tone knife, which is similar to a utility knife, only smaller.

Once you've completed the replacement sky, apply glue on the original sky.

Because the replacement was made on thin paper, affix a blank sheet over the original sky first, to keep its color from showing through the replacement.

Cut the replacement sky to fit within the sky space and around the character, and glue it down. Working on a lighted tracing table will help. The tone knife is sharp, so handle with care.

Decorating with Patterned Tape

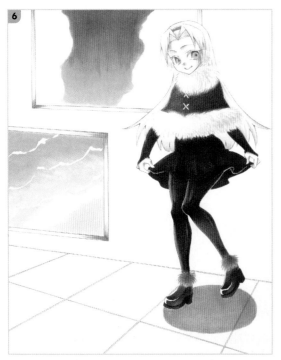

Patterned tapes are available at most stores where arts and crafts supplies are sold. They come in a variety of patterns, so find something that will suit your work.

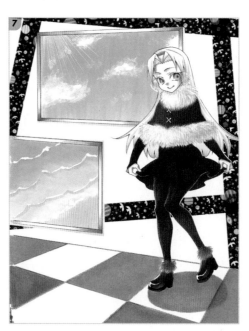

The background wall is fairly plain, so try dressing it up with patterned tape. You could also try drawing patterns with your markers—some possibilities can be found at the end of this book—but patterned tape is an easy, fun way to add a creative touch that has some uniformity to it, while saving time.

From Start to Finish

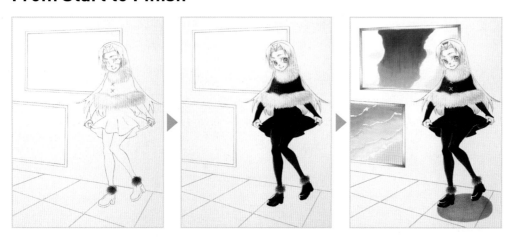

Because the illustration is simple, I chose to use the primary colors of red, blue and yellow to give it a little more glamour. To prevent the overall scene from becoming too bright, I added in some slightly less saturated colors. I started with character's skin and hair, keeping them light, then introduced bolder, darker colors for her clothing. I also left some white paper visible to create sharp contrast.

FIXING MISTAKES & GROWING YOUR SKILLS

Everyone makes mistakes! In this chapter, we'll teach you how to fix mistakes and introduce some advanced techniques that build upon the basic skills you've developed so far.

SECTION 1

MAKING CORRECTIONS

Don't give up when you make a mistake. Try these techniques to correct and recover your illustration.

COMMON FIXES

Smeared Color

Touch up with white

Opaque white is great for touching up small areas where you won't be applying color later.

Lift with No. 0

Colorless blender will remove color to a degree and is recommended if you plan to add color to the area after the fix.

Uneven Color

Add more layers

Layer color over the areas that are too light. This may darken the entire image more than you originally wanted.

Use colored pencils

Correct the unevenness using colored pencils. However, the exact color can be difficult to match.

Overpowering Shadows

Darken the body

The problem is the contrast between the shadow and the body. Lessen it by darkening the body.

Layer lighter color

Layer color on the shadow, using lighter color than the shadow. The shadow will look lighter.

OTHER REMOVAL METHODS

Cutting Out by Hand

If a lot of color has smeared outside the lines, cut out the original image as a last resort, and paste it onto a new sheet. This method only works well when the image is easy to cut out. Use your drawn lines as a guideline for cutting. After transferring the image to new paper, trace over the drawn lines of the cutout to make them look consistent again.

The illustration cut out.

The smear left behind on the original paper after the cut.

TRY IT!

Shave lines with a cutter

Lines made with pigment pens, in which the ink sits on the surface of the paper, can be shaved using a cutter to make small corrections. However, this method won't work for areas colored with Copic or similar markers, because the ink absorbs into the fiber of the paper too much to remove.

Shaving lines too rigorously will cause the surface to get rough or make a hole in the paper.

Erasing Digitally

Computer software programs such as Adobe Photoshop have tools for making corrections, if you're willing to convert your drawing to a digital image. Many have an eraser tool that allows you to select and delete the area you want to remove. Another method lets you specify a "clipping path" to select the part of the illustration that you want to keep. The latter requires a little more knowledge.

Eraser tool

Eraser tools in programs such as Adobe Photoshop allow you to remove parts of an illustration digitally.

Clipping path

In this example, the dotted line represents the clipping path created to digitally cut out the star, removing the smeared area.

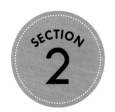

ADVANCED TECHNIQUES

Your illustrations will improve when you choose colors with a purpose in mind, asking yourself why something should be the color you're making it. Let's review some additional considerations that will expand your coloring ability and options.

CONSIDERING THE LIGHT SOURCE

How Light Affects Color

Light reveals color and how we see it. Wherever light is present, shadow should also be present. When coloring, consider where the light is coming from and how it hits what you're coloring, as well as the shadows resulting on your object and cast by the object onto the surface where it sits.

Also consider the light reflecting from the ground onto the object. Reflected light is weaker than direct light, and a little darker.

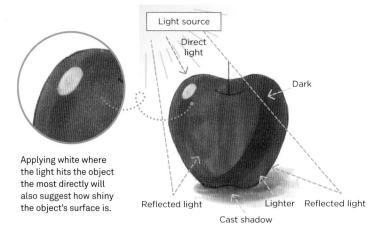

Applying white where the light hits the object the most directly will also suggest how shiny the object's surface is.

PUTTING COLOR IN PERSPECTIVE

Color Changes with Distance

Perspective also affects how we perceive color. There are two kinds affecting how we add color: color perspective and aerial perspective.

Color perspective relies on the optical illusion that warmer colors (yellow, orange, red) look closer to the eye than cooler colors (purple, blue, green). So, objects in the distance should be cooler in color than those that are closer to the viewer.

Aerial perspective suggests that colors become lighter and less intense in the distance. Colors closer to the viewer should be darker and brighter.

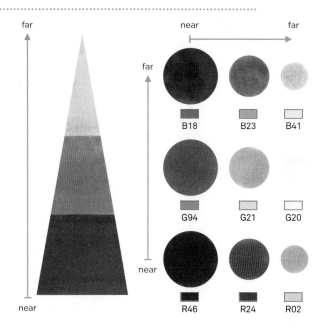

LAYERING THE SAME COLOR

Color Darkens with Every Layer

A big challenge of marker coloring is unevenness, especially in large areas. Layering the same color multiple times will get rid of the unevenness, but the color can get dark, as these examples show. Layering with a color that's one level lighter than the original will help correct uneven color without making it too dark.

Color used
☐ BV00

Color used
☐ Y21

Color used
☐ V04

Color used
☐ YG03

Color used
☐ RV32

Color used
☐ G20

Color used
☐ R02

Color used
☐ BG49

Color used
☐ YR01

Color used
☐ B41

Color used
☐ E13

One layer Two layers Three layers

GRADATION WITH MULTIPLE COLORS

Ordering the Colors

Multiple-color gradation can be difficult if you're unsure about the color between the starting color and the ending color. The resulting impression changes greatly depending on the transitional middle color you choose.

Colors used

V20 YG61 BG23

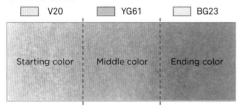

Starting color Middle color Ending color

Decide the middle color after choosing the other two. Use the color wheel below to help you choose a pair of starting and ending colors, and either a warm or cool middle color. On the next two pages are some Copic combinations to help get you started.

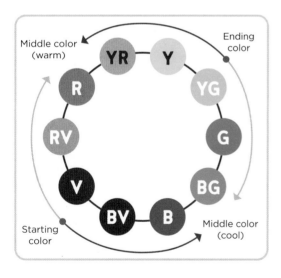

Middle color (warm)
Ending color
YR Y
R YG
RV G
V BG
BV B
Starting color
Middle color (cool)

Colors used

BV00 RV11 YR65

Colors used

V04 B66 YG91

Colors used

V91 BG93 E84

Colors used

RV32 Y32 G40

Colors used

R02 V12 BG57

Colors used

YR01 YG13 B93

Colors used

☐ Y21 ▨ RV63 ▨ BV11

Colors used

☐ G20 ▨ YR82 ▨ E31

Colors used

▨ Y28 ▨ V15 ▨ BV08

Colors used

▨ BG49 ▨ YG17 ▨ R22

Colors used

☐ YG01 ▨ RV02 ▨ R43

Colors used

☐ B00 ▨ BG72 ☐ W-2

Colors used

☐ YG03 ▨ R21 ▨ V95

Colors used

☐ B41 ▨ V01 ▨ E04

Colors used

▨ YG93 ▨ V93 ☐ E71

Colors used

☐ E31 ▨ R83 ▨ YR21

Colors used

▨ G02 ▨ B52 ▨ BV02

Colors used

▨ T-3 ▨ V05 ▨ R46

TRYING DIFFERENT SURFACES

There are so many kinds of paper that differ in color, texture, and thickness. Pay attention to the differences in how the color reacts when applied, and the pros and cons of each surface.

SMOOTH VS TEXTURED PAPER

Marker and Bristol Papers

Marker paper is smooth and has a familiar feel and look. Bristol (shown) is smooth but slightly firmer and thicker, making it better if you do much color blending.

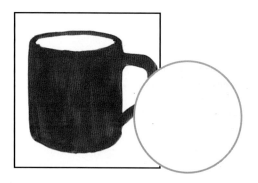

Watercolor Paper

Watercolor paper has a rougher texture that offers a different artistic look. However, markers tend to smear on this paper.

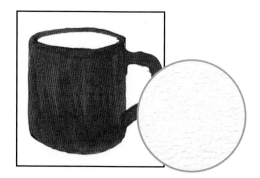

ART PAPER

Woven Material That Resists Color

Some art papers are woven with materials that provide a visual accent but may resist color. This example is woven with gold material that remains visible after coloring.

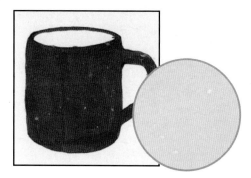

Woven Material That Accepts Color

Other papers are woven with materials that accept color to a degree. The example shown features a feather-like accent. Lighter colors work best on these papers.

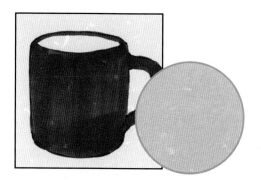

SPECIAL FINISH PAPER

Glossy Paper

Glossy paper has a slick surface that's challenging but can be fun. Large areas of color tend to look messy because the ink doesn't absorb, but it won't come off if dried fully.

Metallic Paper

Metallic colored papers have a shine to them that remains even when marker is added. Make use of the shine in your illustrations.

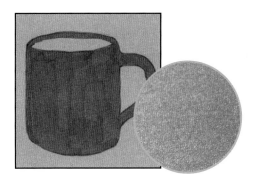

PATTERNED PAPER

Dots

By drawing on colored paper, patterned illustrations can be made easily.

Stripes

The color of marker that you layer onto the colored paper gives the pattern a new look.

Handmade

Creative patterns such as this floral design can dress up plain-looking areas.

Newspaper

Everyday papers like newsprint can add interest and whimsy to your illustrations.

ANALOG > DIGITAL

Tips for Digitizing Copic Artwork

Hand drawn artwork and manga manuscripts are very beautiful, but it's essential to digitize them in order to publish online. The following guide includes a few tips to preserve the hand drawn look and vibrant colors when digitizing your artwork.

Using Adobe Photoshop

Original

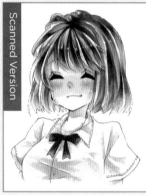

Scanned Version

The hand drawn look is lost!

It can be difficult to capture the colors of Copic markers on the screen. Use photo editing software, such as Adobe Photoshop, to make color corrections and get the hand painted touches back that can get lost during the digitizing process.

❶ Color Correction with Color Burn

Color Burn is useful when the color has faded from the original illustration after being digitized. It allows you to make contrast adjustments without changing the hue. Simply create a new layer of light gray or other color on top of the original illustration, then apply the Color Burn Blend Mode from the Blending Options menu.

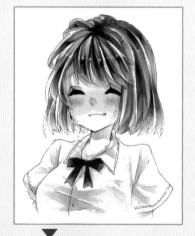

When a layer of light color is added and Color Burn is applied, the color overlaps the entire image, increasing the contrast.

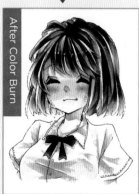

After Color Burn

TIP

Depending on the colors layered, the finished contrast and ambience will change. Try different colors until your illustration appears closer to the original artwork.

❷ Color Correction with Multiply Blend Mode

With this method, you'll layer the color range with the same colors as the original artwork when the color is lost. By layering with Multiply Blend Mode, you can revert back to the color of the original artwork if the color has become too light. Add a layer with a rough sketch of color in the areas where it's missing from the original artwork, then apply Multiply Blend Mode from the Blending Options menu.

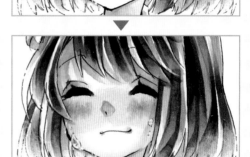

TIP

The point is to layer light layers of the same color as the original. But in some cases, a slightly different color may be more effective.

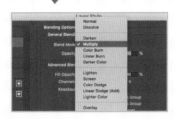

This technique is useful for colors that cannot be corrected using the Color Burn method only. You can make adjustments by "multiplying" multiple layers to match the gradation and tonal variations of the shadows. Multiply Blend Mode creates a similar effect to painting.

❸ Restoring the Original Color

In some cases, you'll notice the hue change after being digitized. When this happens, you can make adjustments in order to make the digitized version more closely resemble the original. In this example, we'll focus on restoring the color of the bow.

Soft Light & Overlay

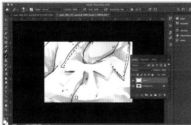

If the color becomes dull, it's useful to add light color. Create a new layer and add white or another light color to the area where you want to adjust the color. Next, select Soft Light or Overlay Blend Mode from the Blending Options menu. Both options blend the color and create a soft impression.

Digitize Original Artwork Using Your Phone

Even if you don't have a scanner, you can digitize original artwork using the camera on your phone.

Using Your Phone

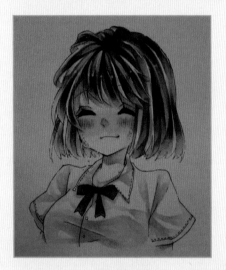

Take a photo of your original artwork using your smart phone. Next, upload the photo to your computer. The appearance of the image may have become compromised during the digitization process, so you may need to make a few adjustments. We used Adobe Photoshop in the guide below.

TIP **Light is important when taking photos**

Make sure that the camera lens and the surface of the original drawing are level when you take the photo. And make sure to consider the light source when shooting—a flat light source is best so there are no shadows.

Level Adjustment

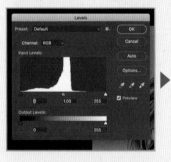 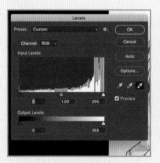

Color Balance Adjustment

 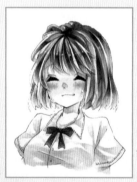

From the Image menu, select Adjustments > Levels, then use the eyedropper tools to select the darkest and lightest spots in the image. This will determine the dark and light standards for the image.

From the Image menu, select Adjustments > Color Balance. Use the sliders to adjust the overall color balance.

TIP **Use a photocopier**

If you don't have a scanner, you can also use a photocopier at a library or copy shop. This is also a good option if your original drawing is on the larger side. After you scan it into the photocopier, save the file on a flash drive or email it to yourself.

RGB vs. CMYK

There are two primary color models used in design: RGB and CMYK. RGB refers to the primary colors of light—red, green, and blue—which are used in computer monitors, phone screens, scanners, digital cameras, and television screens. CMYK refers to the primary colors of pigment—cyan, magenta, yellow, and black—which are used in printing. Digital illustrations created on the computer are RGB, while hand drawn illustrations colored with Copic markers are CMYK. Anything that is printed is also CMYK, so digital illustrations must be converted to CMYK for printing. The following guide explains the difference between the two color models.

RGB Color

Red, green, and blue light can be combined to create a variety of colors. When 100% of each color is combined, it creates white light, which is known as additive color mixing. Since monitors reproduce color with light, any time you view an illustration on a computer or phone, the colors are displayed with RGB color. RGB offers a wide range of colors, and certain colors can't be reproduced with CMYK printing. When RGB color is converted to CMYK, the resulting image can appear slightly dull.

CMYK Color

With this system, cyan, magenta, yellow, and black ink are used to create a variety of colors. When 100% of each color is combined, it creates black, which is known as subtractive color mixing. Copic markers use ink, so the resulting illustrations will use CMYK color. However, if you scan your illustration into the computer, it will be converted to RGB color on the screen, and then converted back to CMYK color for printing. This process can make the colors appear dull. With printing, it's also possible to add special ink called spot color to produce fluorescent or metallic colors.

RAMIRU KIRISAKI

About the Artist

Ramiru Kirisaki is inspired by Japanese myths and ancient history, and she incorporates these elements into her fantasy world artwork. In addition to illustrating children's books, she participates in Copic marker demonstrations. Visit her website at www. ramiru00.tumblr.com

Materials

Copic markers, Copic Multiliner pens in various colors, Dr. Ph. Martin's colored inks, white pen, opaque white, blue sharp-point pen, Albireo watercolor paper

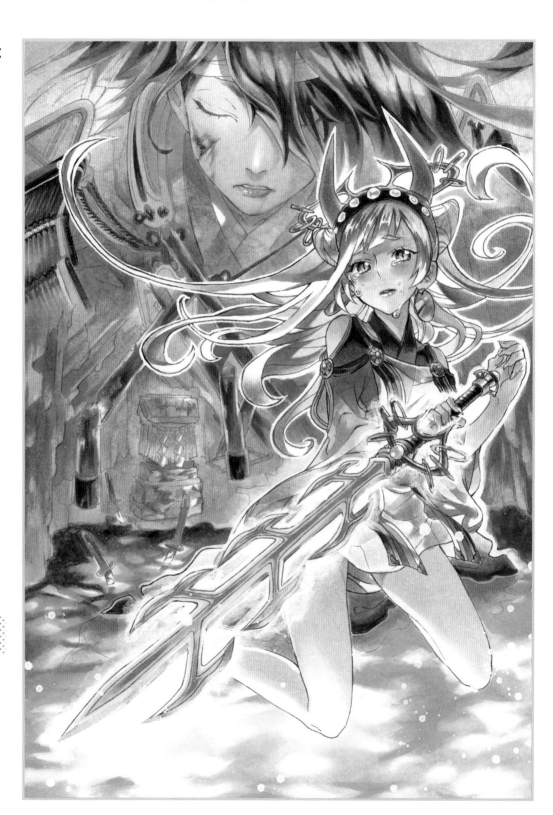

Think About the Story Within the Illustration

This illustration is meant to be the start of a story. The first step in creating an illustration like this is to decide what information you want to include about the character and her situation, and how much of the character's world you want to show.

Beginning sketches focus on key elements that we want to include, such as the character's horns and a seven-branched sword, a mystical ceremonial artifact known in Japan.

Details of the character's design, including clothing, accessories and any other accompanying information, should be well thought out and organized in preliminary sketching (shown at right) before the final drawing and coloring begins. This reduces the time spent on working out these details during the drafting stage.

Plan a Complete Composition

Fitting multiple elements into a drawing can get complicated. Computer software can help you make a plan. Elements can be photographed or scanned, or recreated digitally, then combined and manipulated, allowing you to play around with placement and sizing possibilities. You can also check the perspective and simplify or add elaboration to the scene.

Draw a rough draft based on a printout of your plan, then use tracing paper to make the final line drawing. Draw in the details at this stage to reduce the time you spend wondering on the paper later.

Preliminary plan

Rough draft

Create the Final Line Drawing

Use a tracing table to help you transfer lines from the rough draft to your final drawing. If the draft is too light to see through the paper, scan it to adjust the darkness of the lines, then print it and trace it. As you draw, consider the colors you'll want certain elements or parts to be, and the areas you want to emphasize, then change the colors or details of their lines. Finalize the image as you go, making lines thinner or thicker, deciding where the areas of strongest light are, and matching your drawn lines to the colors you plan to add.

TIP

Fix with sand eraser

A sand eraser requires a thicker paper to use without damaging the surface, but it can remove ink lines that can't be erased with a regular eraser. However, don't rub too hard or the surface may become too disturbed to accept colors later.

Line drawing

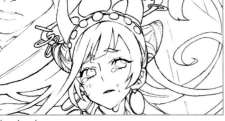

Completed illustration

From Start to Finish

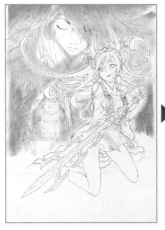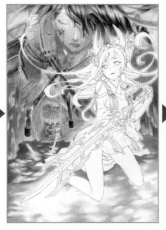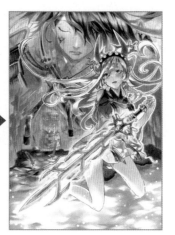

I start with the background first, keeping in mind what colors I'll add later. I like to change the position of the light and shadow for the person in the background and the character in the front to guide the viewers' eyes. The key to this illustration is the use of white to frame both of the characters.

CHAPTER **4**

COPIC MARKER FAQS

In this chapter, two Copic masters share their expertise by answering some frequently asked questions. We'll also take a closer look at how the markers are made and get some practical tips for storing and refilling.

COLORING Q&A

with Ramiru Kirisaki and Suzu Kawana

Two illustrators who have demonstrated Copic products at events and whose work you've seen in this book answer questions and offer technical tips and advice.

Q: There are so many Copic colors available. How should I choose colors when starting to use Copic?

Suzu Kawana: First, start with the colors that appeal to you most. I think you will most enjoy using colors you like. As you start using them in that way, you start to understand the trends of the colors you use. Then you can collect the necessary colors.

Ramiru Kirisaki: It may vary depending on the motifs you want to color, but based on the assumption that you want to color characters, I think it's good to start with the colors that are easy to use for skin tones, in the E (earth colors) and YR (yellow-red/orange) series. In addition, consider the unique colors of your character. Other than that, light blue or light purple might

be useful. Using blue or purple on the background can make characters look more three-dimensional, because cooler colors tend to look more distant than warmer colors.

Kawana: Buying a set of colors can also help you discover your preferences. If you find a color that you like in a packaged set, then you might find you like other colors in the same set. You can also watch Copic demonstrations online and see what colors other artists are using, then try them out yourself.

Q: When is it best to use the broad tip instead of the brush tip?

Kirisaki: The broad tip isn't used as frequently as the brush tip, but it's very convenient for coloring large areas evenly.

Kawana: I agree. When trying to color a big area evenly, the broad tip is better than the brush tip.

Kirisaki: When we apply color only once to an area, it's hard to avoid unevenness. So, when you layer colors to eliminate the unevenness, the broad tip is convenient, since it has a wider area that is in contact with the paper.

Q: Do you have any tips for coloring evenly?

Kawana: I don't care too much about unevenness as I color along the form of an object. Also, if the color looks uneven, it's usually because it was applied just once. If

Understanding color perspective

Our eyes naturally perceive warm colors such as red and yellow as being closer to us than cooler colors such as blue and purple. Applying this principle in your illustrations—assigning warm colors to the foreground and cool colors to the background—will give them more depth.

you layer the same color or a different color over it, the unevenness won't be noticeable.

Kirisaki: Colors that are much darker than the paper more easily become uneven, as opposed to lighter colors. In such cases, layer the same color many times to eliminate the unevenness. However, layering with the same color can darken it quickly. In that case, layer with a color that's a level lighter.

Q: Do you have any tips for color gradation?

Kirisaki: Layer the color before the ink that was previously added dries.

Kawana: You shouldn't use colors that are too difficult to create gradation with. Base the gradation on the natural relationship between the starting and ending colors (see pages 16 and 118). In addition to that, I think it's a good idea to use paper that is best suited for gradation, such as watercolor paper or drawing paper. Technique is important, but the paper you choose is equally as important.

Kirisaki: Try coloring on many kinds of paper to find a paper that suits your style.

Q: Do you have any art materials you recommend combining with Copic markers?

Kirisaki: Depending on the artist, some choose to combine them with various kinds of media. I often see colored pencils used. I often use colored ink. Colored inks are classified as the same dye as Copic, so they are compatible. And the color is very bright.

Kawana: Some artists are drawing outlines with colored ink and then coloring with Copic, right?

Kirisaki: I do that occasionally.

Kawana: I recommend colored pencils. As explained in this book, I think the compatibility of colored pencils and Copic is pretty good.

Kirisaki: You can create nice textures by using colored pencils and pencils in general on small details.

Q: Where should we use fluorescent colors?

Kirisaki: I can't say anything here because I rarely use fluorescent color. It's hard to reproduce in print, so I tend to avoid using it.

Kawana: No fluorescent colors are available in Copic Ciao. Fluorescence is hard to use, isn't it? I only use it when showing original drawings at exhibitions and such, so there is little occasion to use it.

Kirisaki: You can use it to color illustrations that will not be printed. I often draw with the assumption that it will be printed, so I don't have the option of using fluorescent colors.

Kawana: It might be cool to draw your signature in fluorescent colors [laughs].

Q: Which is better, between Copic Sketch and Copic Ciao?

Kawana: It depends on whether you're a beginner or someone who has used markers to a certain extent, and the number of colors offered is different. I'd recommend Sketch if you'll be using them for a long time. It's important that you have many colors, either way. Of course, there's no rule that you can use only one kind, so you could use both.

Kirisaki: If you're a beginner, you could buy Copic Ciao first and try it out to see if it suits your style. Some types are made for beginners or have slightly different features. The caps on Copic Sketch are nice because they have little air holes, making them less of a choking hazard and safer for children.

Kawana: I buy Copic Ciao to try out a color, then I buy Copic Sketch when I know I'll use the color in the future.

Q: Is there a good way to know when the ink will run out?

Kirisaki: It's quite difficult to determine when the ink will run out.
Kawana: The first way to determine this is to look at the chisel tip. When a white line appears, it can be a sign that the ink is getting low.
Kirisaki: Same as the chisel tip, the brush tip turns white, so it's better to be aware of one of them.

Almost out of ink

When the ink is running low, the color of the tip becomes faded and white lines are visible on it.

Q: How do I refill the ink?

Kawana: I pull out the chisel tip by hand and pour ink into it. If you're coloring with Copic, your fingers will get dirty anyway, so you shouldn't worry about getting your fingers dirty refilling. As you're refilling, be aware that when you remove the cap from the other side of the marker to create an escape for displaced air, the exposed nibs may accidentally mark whatever they touch.
Kirisaki: Make sure you don't have an illustration underneath when you refill the ink. This is a must.

Q: How do you store illustrations drawn with Copic? Also, how do you store Copic markers themselves?

Kirisaki: Illustrations drawn with Copic should not be exposed to sun.
Kawana: Copic illustrations are very light-sensitive. When I store them, I pay particular attention to keep them away from sunlight.
Kirisaki: Regarding the storage of Copic markers, I store them vertically in a clear case (see next page), separated by color family. This makes them easy to access and very convenient to use.
Kawana: I've selected the colors I use most often and store them in a soft case called a Copic Wallet (see next page).

Q: What first attracted you to using Copic markers?

Kirisaki: My reason is because my favorite artist was using them.
Kawana: I saw them in a shop that sold drawing materials.

Q: Finally, please tell us why you continue using Copic markers.

Kawana: Copic helps me draw in a way that suits my style. I've tried many different materials and finally arrived at Copic.
Kirisaki: There are many reasons, but again, I like the texture of drawing.

Clear plastic storage case

There are a variety of art marker storage options available for keeping your Copic markers organized. The space at the bottom of this case is divided so that each marker has its own spot. The markers are stored vertically, making it easy to find colors and keep them sorted how you want them. The opened top lid can fit around the bottom of the case so that it doesn't get in the way.

Copic Wallets

Portable soft-sided storage is useful for when you need to carry your markers with you. You can store accessories such as extra nibs in the side pockets. Copic Wallets hold 24, 36 or 72 pens, and the largest one has a shoulder strap for easier transport. Other similar carrying cases are available from other manufacturers, though their features and quality may vary.

TRY IT! **Quick draw challenge: Which 12 colors of Copic Sketch would you choose?**

We asked illustrators Ramiru Kirisaki and Suzu Kawana to choose 12 colors from the Copic Sketch collection that they would recommend for coloring a black-haired character. In addition to these colors, No. 0 (colorless blender) is also handy to have.

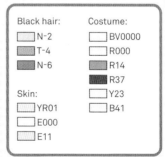

Ramiru Kirisaki's picks

Black hair:
- BV23
- BV25
- V01

Skin:
- RV42
- YR000
- E50

Costume:
- RV63
- Y00
- YG11
- BG13
- B66
- E44

Suzu Kawana's picks

Black hair:
- N-2
- T-4
- N-6

Skin:
- YR01
- E000
- E11

Costume:
- BV0000
- R000
- R14
- R37
- Y23
- B41

COPIC Q&A

A Copic representative answers a few common questions about Copic coloring markers and other Copic products.

Q: How is Copic ink made?

Copic ink uses alcohol-soluble dye. Most of the Copic colors are very light, so the difference in the dye concentration can create quite different colors.

For this reason, we need to pay close attention to color management when we manufacture ink. Prior to production at the factory, a dedicated staff is responsible for determining the ink colors, and only heavily tested inks are filled into the ink body. In addition, the post-production Copic markers are tested for drawing.

Q: How are the markers checked for quality?

After assembly at the factory, a dedicated staff member conducts a multiple-point inspection of each marker (assessing the color quality, label print clarity, air-tightness of the ink barrel, etc.) and ships only those that pass each test. Made in Japan, Copic markers have gained recognition worldwide for their high quality, and they are distributed in more than 50 countries.

Q: How are the color names determined?

Many Copic users are accustomed to identifying marker colors by their letter/number codes, but the markers also have names. The names of Copic colors include familiar references that are easy to imagine, such as plants and food. They have become more imaginative over time. Hues such as Stratospheric Blue and Abyss Green came about when the developer had to get creative in generating names for new colors in growing collections.

Q: I often mistakenly buy colors I already have. How can I keep better track of what I have?

It must mean that you love those colors! I recommend getting the free Copic Collection app to help you manage what you have, browse colors, and make shopping lists. You can also view color information and share your artwork on social media.

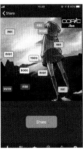

The Copic Collection app

Q: Can I use Copic colors on surfaces other than paper?

Copic colors aren't suitable for direct coating of nonporous surfaces such as metal or glass, because these surfaces won't absorb the ink. However, you can apply color if you treat the surface first with a product such as a matte spray paint that will help the ink take hold. However, the durability of inks applied to surfaces this way is not guaranteed.

Q: What is the best way to store Copic markers?

Horizontally is the preferred way to store them, but if they contain enough ink, their storage orientation has little impact on their performance. So, packaged sets are stored vertically with the brush tip up. However, it's not recommended to store fluorescent (F) Copic Sketch colors vertically. If you store Copic markers long-term for more than one year, natural sedimentation of the pigments may affect their color. Turn them upside down and let them stand for a while before using.

Q: How do I refill the ink?

Refilling the ink in your Copic markers is essential to making them economical to use. The newest Copic ink refills come in a pen-shaped bottle with a thin nozzle that easily inserts into the marker barrel once you remove the nib. Some discontinued ink refills require different refill methods. Be careful not to refill your markers over your drawing work, in case of spills.

Getting support with Copic

For more online about markers, pens and other products:
http://copic.jp/en/

For answers to more FAQs:
https://copic.jp/en/support/

For updates on Twitter and Instagram:
@COPIC_Official

For videos on YouTube:
COPIC_Official channel

ANALOG > DIGITAL

Submitting Your Files to the Printer

There are a few things to consider if you're planning to have your work professionally printed. The following guide includes some helpful information to review before submitting your files to the printer.

Setting Up Your File

❶ The Basics of Book Printing

If you're planning to print your work as a book, it's helpful to know some basic terminology in order to make sure you set up the file correctly. The diagram on the right illustrates the major elements of a book.

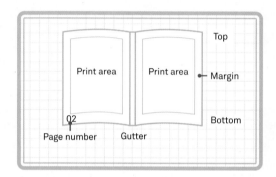

❷ Page Count

Books are composed of units called signatures. Signatures are usually 8 or 16 pages, so your total page count should be a multiple of these numbers, not including the covers (covers are usually printed separately).

❸ Color Settings

If you plan to have your work printed, make sure to use CMYK for the color mode (refer to page 125 to learn about the differences between CMYK and RGB). This is very important as the color will appear differently based on the settings.

❶ Include Registration Marks

When preparing your file for printing, you'll want to include registration marks. There are two types: corner marks and center marks. Corner marks are useful as guidelines for the finished size of the page and the bleed, while the center marks indicate the location of the book's spine, as well as the middle of each page.

1 Finished size line	The page will be trimmed along this line.	
2 Bleed area	Extend images or colored backgrounds ⅛ in (3 mm) beyond the finished size line to prevent any white paper from being visible.	
3 Print area	It's a good idea to keep text ⅛ in (3 mm) from the finished size line; otherwise, you risk text getting cut off during printing.	

❷ Double Check the Bleed & Print Area

If you intend for your image to fill the entire page, which is also known as a full bleed, make sure it extends slightly beyond the edges of the page. This will ensure that the color fills the page, even if there are minor alignment or cutting issues during the printing process. Most printers suggest having the image extend or bleed ⅛ in (3 mm) beyond the edge of the page. In the same way, make sure that the text does not extend beyond the print area; otherwise, it will be in danger of getting cut off.

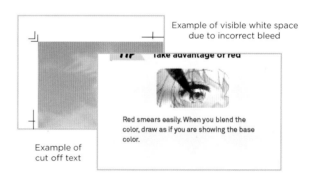

Example of visible white space due to incorrect bleed

Example of cut off text

❸ Generate the File

The final step is to generate your file for printing. Check with the printing company first to make sure you are using a file format that they will accept. Once you submit the file, the printing company will review it to check for color, missing artwork, corrupted text, and other potential issues.

Example print ready file for this page

ANALOG > DIGITAL

Making Products with Your Art

You may think it's difficult to create custom products featuring your artwork, but there are many printing companies that offer a wide range of goods that can be customized with your illustrations. The following guide includes some helpful information to keep in mind when ordering products.

❶ What can I make?

Printing companies can produce a variety of goods, not just books! Consider using your artwork to create notepads, pins, phone cases, and more. You can use these products as a vehicle for sharing your artwork with more people than ever before.

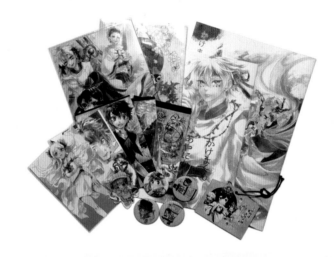

❷ How do I make it?

The first step is to select the printing company you plan to use. Consider factors such as their product range, pricing, and production timeline. Once you've decided on the printing company, prepare your file following the specs they provide. In most cases, the printing company will send you a proof to review. Once you confirm that everything looks good, all you have to do is wait for delivery!

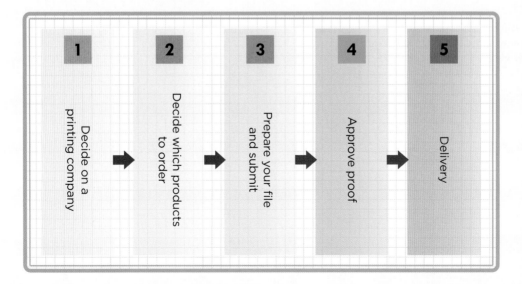

1	2	3	4	5
Decide on a printing company	Decide which products to order	Prepare your file and submit	Approve proof	Delivery

Product Examples

① Pins

Button-style pins are classic promotional items. If the pin style you plan to order is circular, make sure that your artwork fits within the outline and won't get cut off.

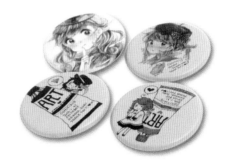

② Key Chains

Acrylic key chains are another staple promotional product. In addition to traditional square and circle shapes, they can be cut out in the outline of your artwork. Some printing companies even offer special finishes like sparkles.

③ Postcards

Use your illustrations to create postcards for marketing, thank you notes, and other correspondence. Printing companies usually offer several different types of paper or card stock, so try different options until you find your favorite.

PATTERN GALLERY

Use these Copic marker patterns as inspiration for your own art. Change the colors or shapes to create patterns for your own original designs.

Striped Patterns

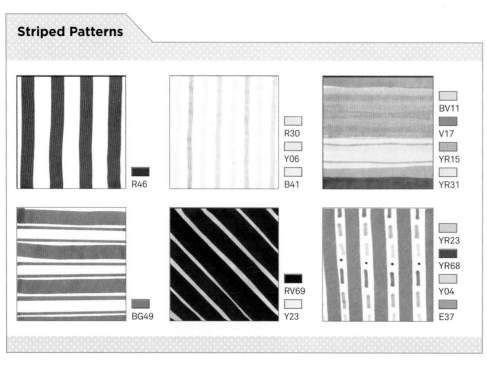

Checkered Patterns

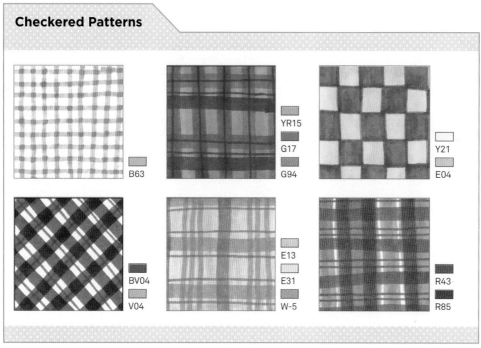

Retro Patterns

V15
RV34
E81

YG01
G85

R14
R29
Y26
BG72

RV52
G40
B12

BV02
BG53
BG70

YG13
G16
E40

BV13
YR30

G17
BG09

R35
BG49

YG05
BG15
BG18

BV25
RV09
W-2

R05
Y17
E79

Floral Patterns

YR68
Y06
E37

B12

RV11
No. 0

Heart Patterns

R43

R24

YR68
B04
E50

Star Patterns

B12
B41
B99

BV11
YR23
Y04

R12
YR31
YR68

Animal Patterns

C-0
N-6

E13
E31
E37

Y26
E13

Dot Patterns

R46

N-4
No. 0

B12
B45

R24
Y04

B99
No. 0

YR15
Y21
Y04
YG03
G94

Assorted Patterns

Chocolate Pattern

E37

Cherry Pattern

R14
G03

Leaf Pattern

G17
No. 0

Spider Web Pattern

N-6
W-8

Wood Grain Pattern

E13
E35
E71

Cat Pattern

R02
N-4

RESOURCES

Blick
www.dickblick.com
Art supply store with locations throughout the US

Copic
www.copic.jp/en/
Official site for Copic markers

Jet Pens
www.jetpens.com
Online stationery store that offers a wide range of
Copic markers, Copic Multiliners, and Copic accessories

Jerry's Artarama
www.jerrysartarama.com
Art supply store with locations throughout the US

Hobby Lobby
www.hobbylobby.com
National craft supply store that carries Copic markers and other
art supplies

Michaels
www.michaels.com
National craft supply store that carries Copic markers and other
art supplies